Pre-Raphaelite Paintings

Julian Treuherz

PRE-RAPHAELITE PAINTINGS

from the
Manchester City Art Gallery

LUND HUMPHRIES · LONDON

in association with the City of Manchester Art Galleries

Copyright © 1980 City of Manchester Cultural Services
First edition 1980
Published by
Lund Humphries Publishers Ltd
26 Litchfield Street London WC2

SBN 85331 432 2

Designed by Herbert Spencer
Book title set in William Morris Troy type, 1892
Filmset by Keyspools Ltd, Golborne, Lancs
Printed and bound by Lund Humphries, Bradford, Yorks

Cover illustrations:
front: William Holman Hunt: *The Hireling Shepherd* 1851 (16)
back: William Burges and Gualbert Saunders: Escritoire 1865–7 (61)

Contents

Preface

Manchester's outstanding collection of Pre-Raphaelite pictures is comprehensive enough to demonstrate the history of the movement, and this is what this book attempts. It describes all works in the Gallery associated with the Pre-Raphaelites and their followers, and it is a greatly enlarged version of the 1974 Gallery publication *Pre-Raphaelite Paintings*. A substantial text has been added, and new acquisitions are also included. All works in Manchester by members of the Pre-Raphaelite Brotherhood are covered, and the choice of works by associates and followers has been made in order to tell the Pre-Raphaelite story most clearly, and to explain the more interesting works in the collection. Where an artist is included, all works by him are mentioned, even if not Pre-Raphaelite in style (as, for example, Millais' late works). Apart from a passing reference to a piece of painted furniture by Burges and Saunders, the Gallery's holding of Pre-Raphaelite Decorative Arts has not been mentioned as it is still growing, and is not as wide-ranging as the Fine Arts collection. A further omission is the work of the Manchester follower of the Pre-Raphaelites, F. J. Shields. It is hoped that the Gallery's extensive collection of his work can be published separately, as in quantity, though not in quality, it overshadows the rest of the Pre-Raphaelite collection.

This book depends very much on the original scholarship of previous writers in the field, and I would particularly like to acknowledge the work of Mary Bennett and Alastair Grieve. Further sources are given in the select bibliography, but in a popular work of this kind it has not been felt necessary to supply detailed footnotes. Thanks are also due to my predecessors at the Gallery, in particular to Elizabeth Johnston. I am grateful to Richard Dorment for supplying fig. xiv and to Deborah Cherry and Timothy Clifford who have read the manuscript and made useful suggestions.

Julian Treuherz

Introduction

In 1848 a group of young artists joined together in a spirit of hot-headed idealism, and formed the Pre-Raphaelite Brotherhood, 'Pre-Raphaelite' because they admired early Italian art before Raphael, and 'Brotherhood' because they liked the idea of a secret quasi-religious society whose initiates had vowed to reform art. They chose the mystic number seven for the number of their members. The chief instigators were John Everett Millais, a former child prodigy who became the most brilliant student of his day at the Royal Academy Schools; William Holman Hunt, who also studied there, but was questioning the Schools' values in the light of Ruskin's writings; and Dante Gabriel Rossetti, a young art student who was dissatisfied with the stultifying routine of conventional art education.

These three persuaded four others to join them: Rossetti's brother, William Michael, who worked for the Inland Revenue, but became an art critic; and three fellow-students at the Academy Schools, James Collinson, a close friend of Rossetti; Thomas Woolner, a sculptor who wrote poetry; and Frederic George Stephens, who soon gave up painting to become a writer on art.

The Brotherhood achieved early notoriety because its members set themselves against the art establishment and painted pictures calculated to offend academic taste. Holman Hunt wrote of their determination, 'ever to do battle against the frivolous art of the day, which had for its ambition "Monkeyana" ideas, "Books of Beauty", Chorister Boys, whose forms were those of melted wax with drapery of no tangible texture. The illustrations to Holy Writ were feeble enough to induce a sensible public to revulsion of sentiment. Equally shallow were the approved imitations of the Greeks and paintings that would ape Michael Angelo and Titian with, as the latest innovation, through the Germans, designs that affected without sincerity the naïveté of Perugino and the early Flemings.'

In 1848 Turner, Etty and Cox were all still working, though approaching the end of their careers, but early Victorian England was not on the whole a period of creativity or advance for art. The Royal Academy was hostile to new influences, both in its Schools and its exhibitions, at which much mediocre work was shown. The Brotherhood particularly disliked the trite subject-matter then in vogue, the dark colours used in imitation of Old Masters (Sir George Beaumont earlier in the century had said that landscapes should be coloured like an old Cremona violin), and the loose, broad handling, mockingly described as 'slosh', for which 'Sir

PRE RAPHAEL
Fig. i
Domenico Veneziano:
The Annunciation, 1442/8

RAPHAEL
Fig. ii
Raphael:
Cartoon for tapestry *The Death of Ananais*,
c. 1515

POST RAPHAEL
Fig. iii
Sir Charles Eastlake (President of the Royal
Academy):
Christ blessing little children, 1839

PRE-RAPHAELITE
Charles Collins:
*Berengaria's alarm for the safety of her husband,
Richard Cœur de Lion, awakened by the sight of his
girdle offered for sale at Rome, 1850*
(see 13 + colour plate 1)

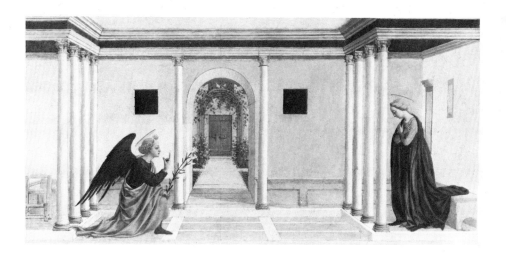

Sloshua Reynolds' was held responsible. Reynolds, to the discontented young artists, stood for all that was wrong with the academic tradition, for he had preached that art should be based on borrowings from the Antique and from the Old Masters. This attitude had originated with Raphael's followers, who according to the Pre-Raphaelites, had elevated Raphael's style into an ideal which dominated the teaching in academies of art. Watered down through centuries of imitation, this style, originally vigorously monumental, had developed into weak and empty rhetoric.

The Pre-Raphaelites' achievement will emerge from consideration of the paintings themselves, but William Michael Rossetti summarised their aims as follows: '1, To have genuine ideas to express; 2, to study Nature attentively, so as to know how to express them; 3, to sympathize with what is direct and serious and heartfelt in previous art, to the exclusion of what is conventional and self-parading and learned by rote; and 4, and most indispensable of all, to produce thoroughly good pictures and statues.'

They were aware of the advice Ruskin gave to young artists in the first volume of his *Modern Painters* (1843): 'They ... should go to Nature in all singleness of heart, and walk with her laboriously and trustingly, having no other thoughts but how best to penetrate her meaning, and remember her instruction; rejecting nothing, selecting nothing, and scorning nothing; believing all things to be right and good, and rejoicing always in the truth.'

The Brotherhood attracted friends and followers: Ford Madox Brown and W.H.Deverell both almost became members, and several others were closely but not formally associated with the group. The personalities and enthusiasms of those involved were too diverse for the Brotherhood to remain a coherent movement for long, but in the beginning a shared style evolved, using clarity of form and outline, bright colour, sharp detail and painstaking naturalism. Similar characteristics were already present in English painting: Dyce had revived the Italian quattrocento style, and Mulready and Lewis had worked with strong colour and minute detail. But the Pre-Raphaelites brought to this manner something quite new, more committed and more deeply felt.

Ideas were of great importance to them, and therefore to their art, which was passionately bound up with poetry, literature and contemporary political and religious movements. Several of them wrote poetry themselves, particularly Rossetti and Woolner, and Brown, Hunt and Rossetti were all devotees of literature, especially of Blake, Byron and Keats. Their reading fed their imaginations and led them to search for pictorial equivalents which were quite different from the literary illustrations then current. Millais and Hunt both joined the Chartist procession in 1848, and Brown was socialist in outlook; Hunt, Rossetti and Collinson were all involved in contemporary religious controversies, particularly to do with the Oxford Movement. Such commitment gave their paintings on modern themes an extra vividness which still tells, even though their topicality is now lost.

To represent these important ideas, they used new methods. They deliberately sought for unorthodox images and avoided well-tried ways of telling a story. Academic rules of draughtsmanship, composition and shading were dropped. Startlingly angular and flat designs, harsh unshaded lighting, bright colours, especially glowing purples and greens, brilliant sunlit landscapes and amazingly sharp details, all these gave their work a power and sincerity lacking in most other English pictures of the nineteenth century. Such intensity remained even when the Pre-Raphaelites had abandoned their original ideals, and left behind the bright and sharp style for the second, more decorative phase of Pre-Raphaelitism current in the 1870s and 1880s.

Plate 1
Charles Allston Collins:
Berengaria's alarm for the safety of her husband,
Richard Cœur de Lion, awakened by the sight of his
girdle offered for sale at Rome (formerly
The Pedlar) 1850 (13)

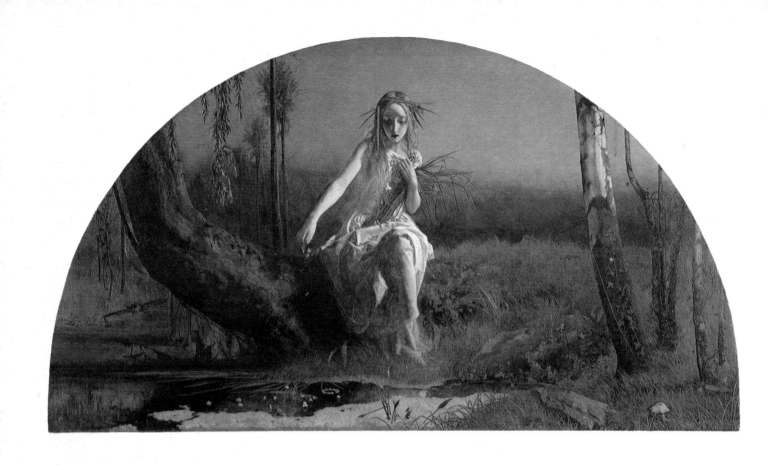

Plate II
Arthur Hughes:
Ophelia 1852 (17)

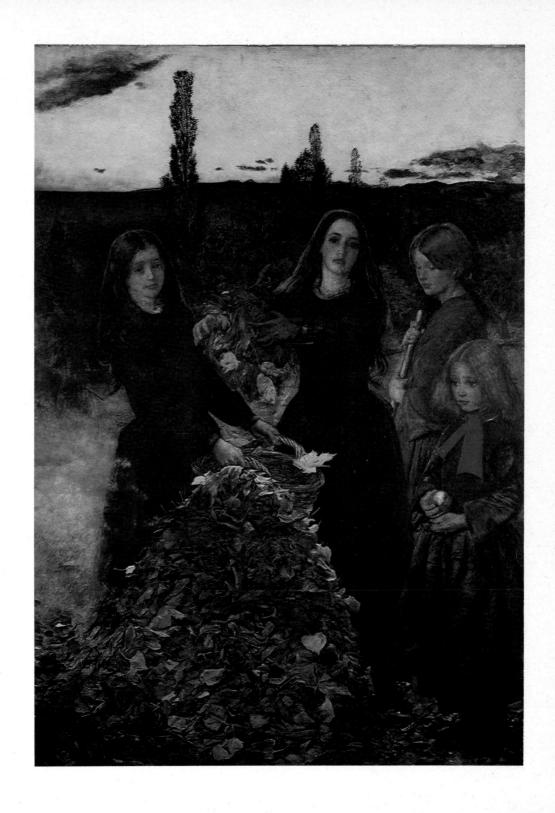

Plate III
John Everett Millais:
Autumn leaves 1856 (24)

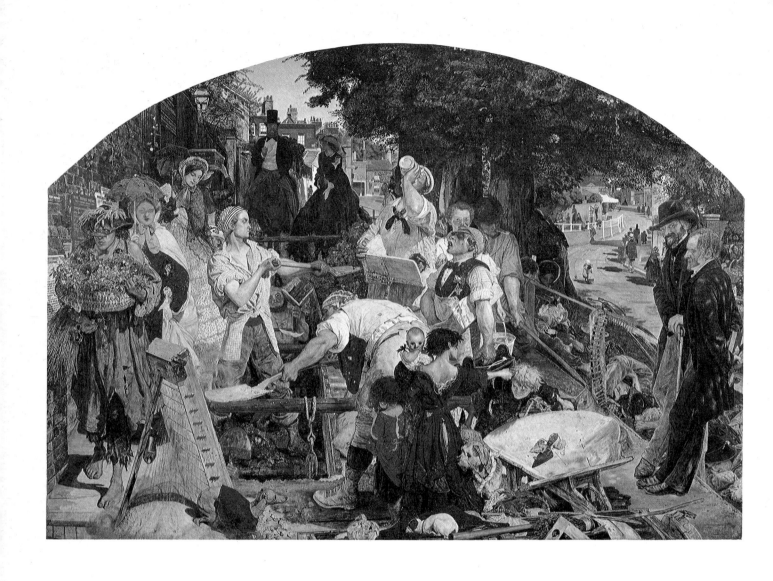

Plate IV
Ford Madox Brown:
Work 1852-65 (27)

Plate v
William Holman Hunt:
The Scapegoat 1854–5 (37)

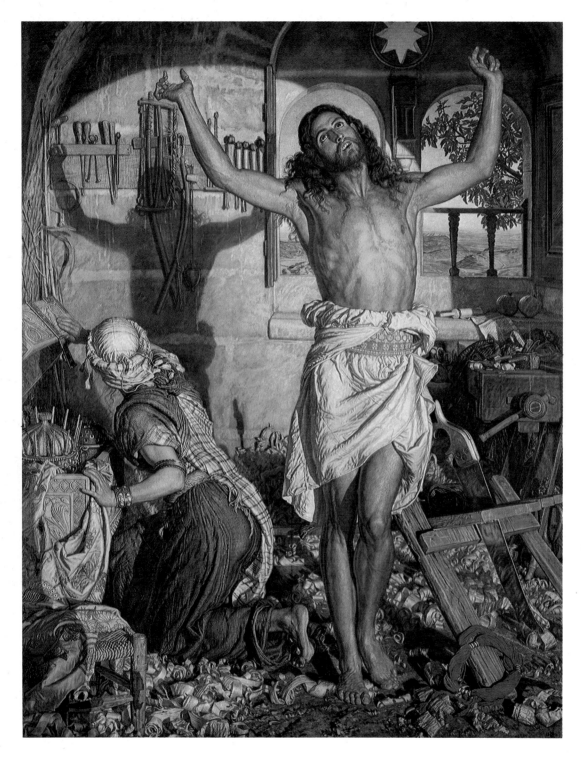

Plate VI
William Holman Hunt:
The Shadow of Death
1870–3 (38)

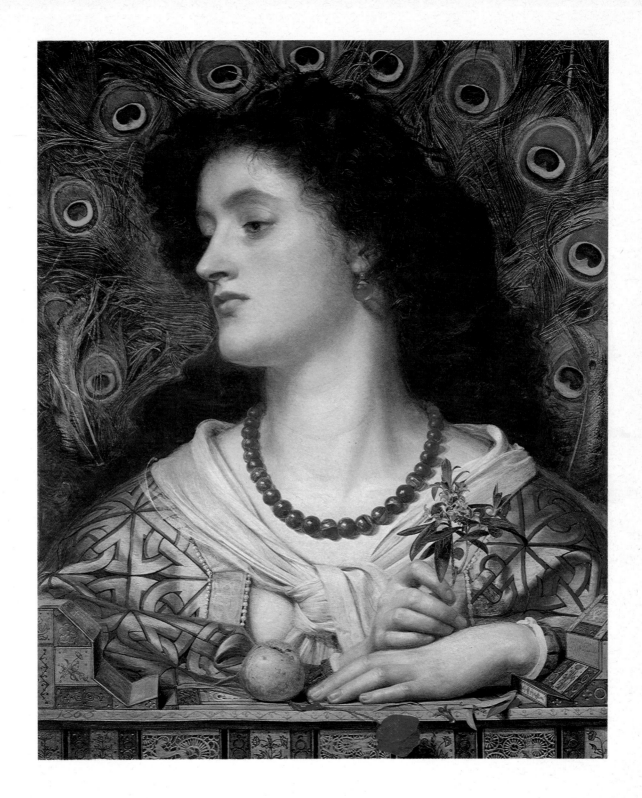

Plate VII
Frederick Sandys:
Vivien 1863 (68)

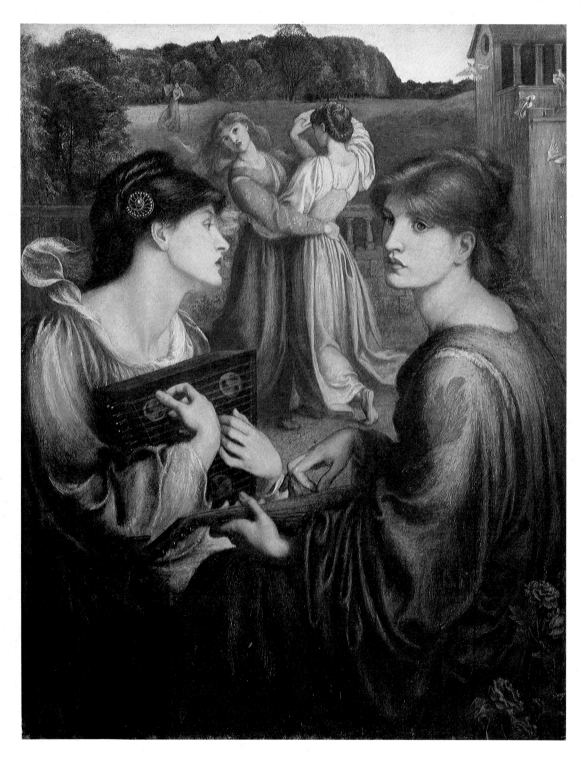

Plate VIII
Dante Gabriel Rossetti:
The bower meadow
1850–72 (70)

The early work of Ford Madox Brown

1
Ford Madox Brown:
Rev. F.H.S. Pendleton 1837

Ford Madox Brown (1821–1893) was closely associated with the Brotherhood. He shared their interests in early Italian art, 'out-of-doors' light and bright colour, and it was to him that Rossetti first came for painting lessons. But when Brown was asked to join the Brotherhood he refused; always an independent spirit, he did not believe in coteries, and said he was 'rather old to play the fool'.

More than his age, his training set him apart from the members of the Brotherhood. He studied in Belgium under academic masters who passed on to him the tradition and discipline of David and Delacroix, a very different training from that which he would have received in England. As a result his early work is dark, dramatic and full of rhetoric.

Brown's earliest work in the collection, however, shows no trace of these influences (1). It was painted at Ghent when Brown was only sixteen, and is a competent and entirely conventional essay in the established portrait style of the day. The sitter, Frederick Pendleton, later became a clergyman, but to the young Brown he was simply a friend who taught the artist to play the violin. Brown inscribed the picture 'à son ami'.

Two Byron subjects owe more to Brown's academic training in the grand manner, and also testify to Brown's passion for English literature, which provided him with subjects throughout his life. The striking *Manfred on the Jungfrau* (2) employs dramatic gesticulation, flying draperies and exaggerated facial expressions. *The Prisoner of Chillon* (3) uses a strong contrast between light and shadow and highly contorted postures. It was with means like these that French history painters achieved their effects. Brown added a touch of the grotesque, which gave his work an added intensity, sometimes verging on the histrionic. His tendency to freeze facial expressions into grimaces remained an unfortunate hallmark of his style all his life.

Brown's most important master was a pupil of Delacroix, Baron Gustav Wappers, who taught at the Antwerp Academy and painted large-scale sweeping historical compositions. It was at Antwerp that *Manfred* was designed in 1840, but it was painted the following year at Paris, where Brown attempted to introduce an effect of outdoor light, something entirely foreign to his academic training. But the result of this early experiment cannot be appreciated, as in 1861 Brown retouched the painting, as was often his habit, and radically changed the colour

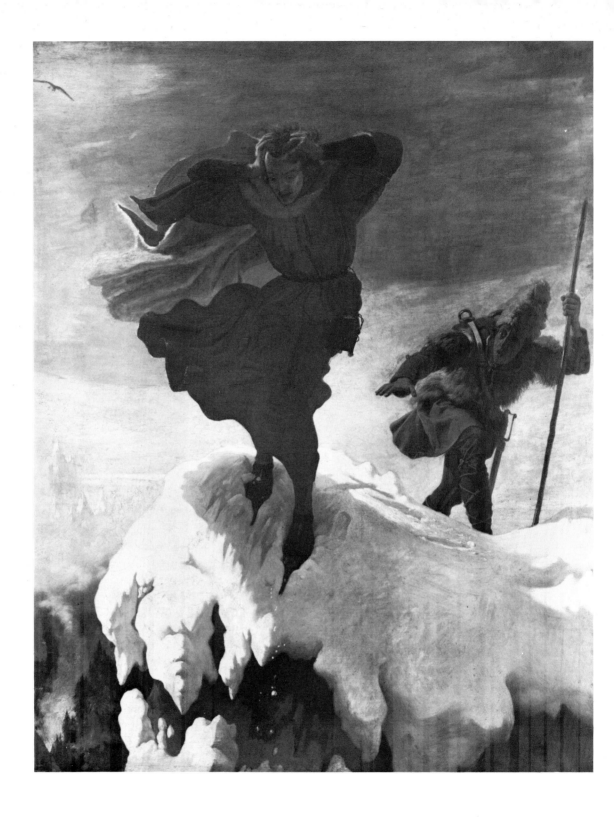

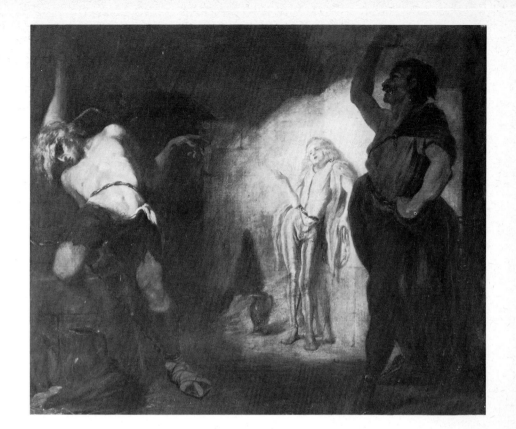

scheme to accord with his later style. The subject comes from Byron's play, *Manfred*, and shows the dramatic moment when the hero, torn by mental and spiritual conflict, is tempted to commit suicide on a precipice of the Jungfrau. The Chamois Hunter enters and draws him back at the last moment.

The Prisoner of Chillon (3) was inspired by Byron's poem about the prisoner shut up in a dungeon with his two brothers, each chained to a column. He is forced to watch his brothers die one after the other. Brown has caught the contrasting characters of the brothers, on the left the one 'form'd to combat with his kind; strong in his frame . . .', and in the centre, the youngest, 'beautiful as day'. Byron's 'pale and livid light' is conveyed by very dramatic lighting, perhaps originating in Brown's study of Rembrandt and the Spanish masters at the Louvre, but the figure style is reminiscent of Fuseli.

Another work of the early 1840s is the painting called *Dr Primrose and his daughters* (4), though it does not exactly correspond with any scene from Goldsmith's *Vicar of Wakefield*. Unlike the Byron subjects, it is a domestic scene, set in a sunny garden. Despite its somewhat heavy technique, it derives from French or Spanish Rococo pictures of fêtes galantes.

The Bromley family (5) shows a similar light colour scheme and is set in a garden, but its nicety of handling shows that the young Brown's style was changing

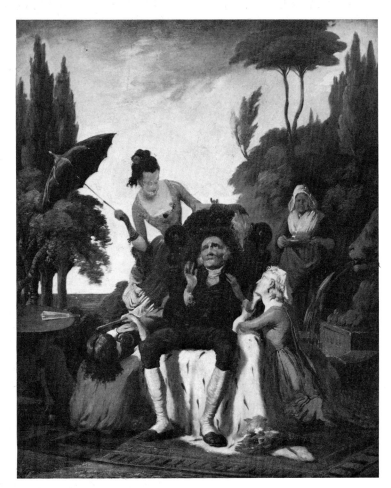

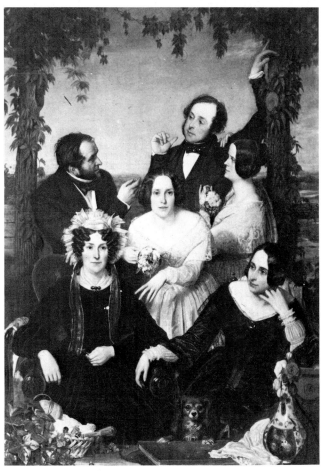

4
Ford Madox Brown:
Dr Primrose and his daughters

5
Ford Madox Brown:
Family group (The Bromley family) 1844

rapidly during the mid 1840s as he absorbed different influences. This time Brown had been looking at the conversation pieces or group portraits by German or Austrian artists of the early nineteenth century, which show families set in gardens, often, as in this case, against a trellis of leaves, the figures grouped closely together, with much painting of fine detail, and the whole exuding an air of bourgeois prosperity. This style was unusual for an English artist, and must be based on what Brown had seen in Europe. But the picture itself was painted in England in 1844 and shows the family of the artist's first wife Elizabeth (*née* Bromley) whom he had married in 1841.

In the mid 1840s Brown had the opportunity to put to good use his European training in history painting. Following the fire and rebuilding of the Houses of Parliament, the Government held competitions to find artists to decorate the interiors with frescoes, and the entries were shown at Westminster Hall. Brown entered two of the competitions, though he did not win a commission. In 1844,

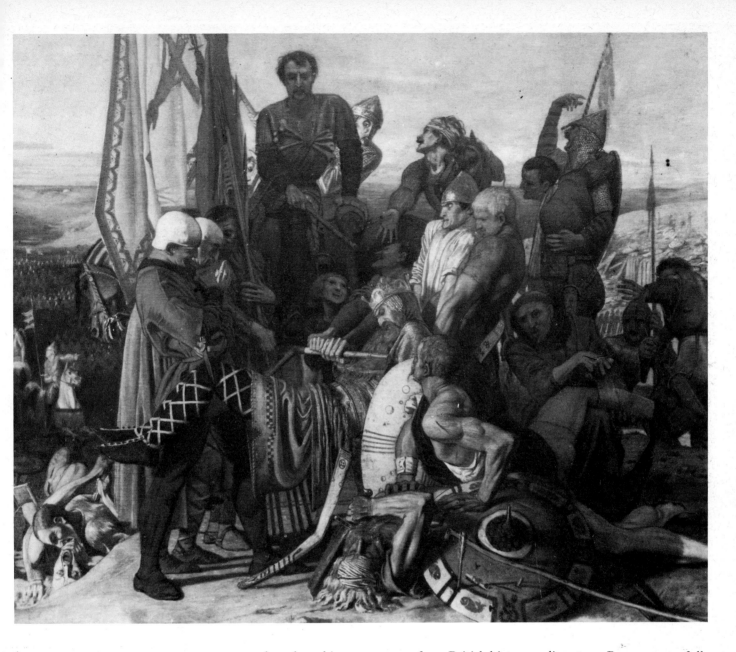

6
Ford Madox Brown:
The body of Harold brought before William the
Conqueror (Wilhelmus Conquistator) 1844–61

when the subject was scenes from British history or literature, Brown sent a full-scale cartoon of *The body of Harold brought before William the Conqueror*. He also submitted the Manchester painting of the same subject (6), smaller than the cartoon, and executed in encaustic wax medium, to demonstrate the technique and colour for his proposed mural. But as it was retouched in 1861, the original apearance may have changed, and the glowing colour is probably darker than it was. Also in 1861 he gave it the Latin title *Wilhelmus Conquistator*.

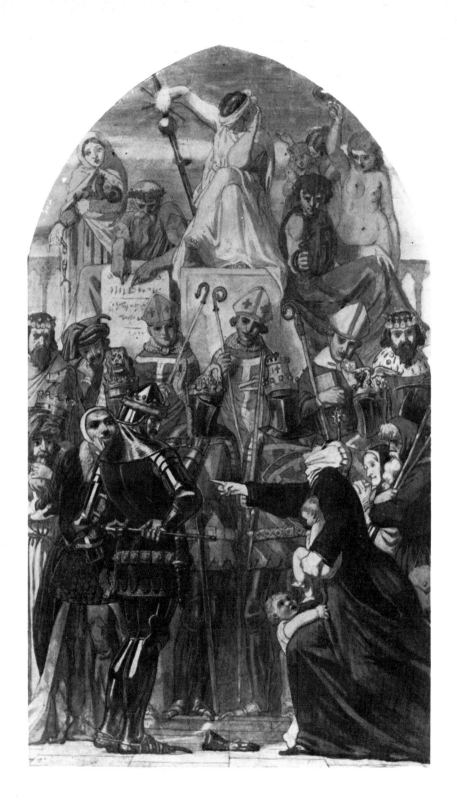

7
Ford Madox Brown:
Study for 'The Spirit of Justice' 1845

8
Ford Madox Brown:
Fragment of 'The Spirit of Justice' 1844–5

A group of burly warriors heave the dead Harold's body before the grim-faced Conqueror, with wounded and fighting figures all around. The main group is emphatically drawn, with vigorous gestures and movement, and composed into an almost flat pattern by the strongly marked straight lines across the surface of the painting. In contrast, stretching back into the picture, are the tents and tiny figures of the distant battle scene.

This respect for the flatness of the surface, so appropriate to architectural murals, is also seen in *The Spirit of Justice* (7), a watercolour version of the cartoon sent to the third Westminster exhibition, held in 1845, when the subjects set for arched wall spaces were 'personifications of the abstract representations of Religion, Justice and the Spirit of Chivalry'. The composition is again flat, dominated by straight lines, with little depth behind the figures. The blindfolded figure of Justice presides over a conflict between power and weakness, represented by a powerful Baron with his hired adviser, and a helpless widow accompanied by aged parents. Justice is flanked by Mercy, Erudition, Truth and Wisdom, and below the throne are the Lords Spiritual and Temporal, and the armed servants of Justice. Manchester also possesses a fragment of the original full-size cartoon, now broken up. The fragment (8) shows the head of the Lord on the extreme right. The history painter B. R. Haydon saw the cartoon and noted in his diary, 'The only bit of fresco fit to look at is by Ford Brown. It is a figure of Justice, and exquisite as far as that figure goes'.

In 1845, Brown travelled to Europe for the sake of his wife's health; tragically she died in 1846 on the return journey. In Basle, Brown admired the work of Holbein, with its smooth, precise modelling and evenly lit bright colour, and in Italy he was impressed not only by Giotto, Masaccio, Fra Angelico and other Renaissance masters, but also by the Nazarenes, a quasi-religious brotherhood of German artists working in Rome. The Nazarene style was a revival of early Italian art, and employed clarity of outline and modelling, bright colour and balanced, formal compositions. At Rome Brown conceived an idea for a grand tryptich called *The Seeds and Fruits of English Poetry*: only the central panel was completed, showing *Chaucer at the Court of Edward III* (Art Gallery of New South Wales, Sydney, fig. iv). The poet is depicted reading to the king, the Black Prince, and the assembled company of courtiers, gaily dressed in picturesque medieval costume. The *Study of a courtier* (9) wearing a yellow hood is for the figure making notes at the bottom right corner of the large painting. Brown took great pains over the study. His diary records that before painting, he bought some yellow brocade, cut out a hood and cape and arranged it on a lay figure. This was all painted in 1847, together with the two details of sleeves on the same study; but the courtier was not painted on to the large picture until 1849.

In the study, as in the large picture, Brown has made clear the exact form of the drapery folds and the way the light falls on them: a comparison with the very sketchy treatment of costume in *The Prisoner of Chillon* of 1843 and the more considered but still not totally precise drapery folds in *The Bromley family* of

Fig. iv
Ford Madox Brown:
*Chaucer at the
Court of Edward III*,
oil on canvas

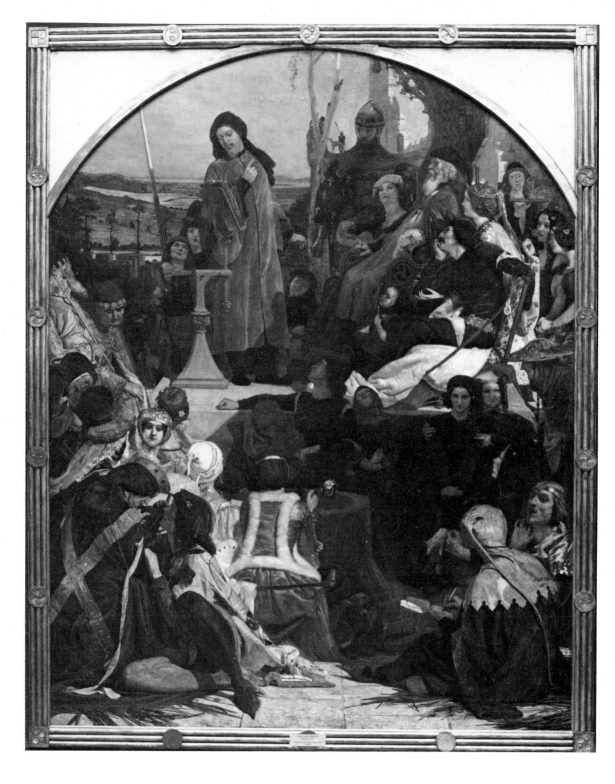

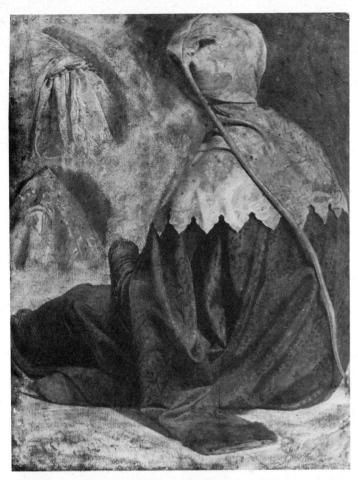

9
Ford Madox Brown:
Study of a courtier for 'Chaucer at the Court of Edward III' 1848

10
Ford Madox Brown:
Two studies of a little girl's head 1847

11
Ford Madox Brown:
William Shakespeare 1849

1844, shows how Brown's style developed towards truth to nature. Nevertheless, despite accuracy in the details, the large Chaucer painting is still an elaborate essay in historical reconstruction, and the design of the painting has an unnatural flatness, similar to *The Spirit of Justice*.

A more modest result of the effect of seeing the Holbeins at Basle is evident in the enchanting picture originally thought to be of two different children, but now known to be *Two studies of a little girl's head* (10). The girl was Millie Smith, daughter of Brown's landlord at Southend, where the artist stayed for a time on his return from Europe. Though dated 1847, it appears in his diary as 'the study of a little girl's head, painted in two views at Southend in '46 on a table napkin'. It is small, simply modelled, and has a restricted colour scheme; a splash of singing red is provided by the flower, the only detail painted with a minute touch. Brown's work is here seen at its most direct and sensitive, unencumbered by too much detail or significance.

Necessarily less spontaneous, because of its subject, is the portrait of *William Shakespeare* (11), dating from 1849. A somewhat airless pastiche of a sixteenth-century portrait, it is, in the artist's own words, 'carefully collated from the different known portraits, and more than any other from the bust at Stratford. The picture is an attempt to supply the want of a credible likeness of our national poet, as a historian recasts some tale, told long since by old chroniclers in many fragments'. The props are deliberately chosen: the books are those which influenced Shakespeare (Plutarch's *Lives*, *Gesta Romanorum*, Boccaccio, Chaucer and Montaigne), and the figure on the tapestry blows the trumpet of fame and holds a laurel wreath.

The early years of the Brotherhood

The Pre-Raphaelite Brotherhood was formed in the summer of 1848, and the earliest painting at Manchester by a Brotherhood member is Millais' *The Death of Romeo and Juliet* (12), a tiny picture filled with agitation. The dead Juliet, in white, is slumped over Romeo's corpse, whilst anxious figures crowd round, their faces naïvely drawn. One figure holds up the empty phial of poison; another, wearing a stylish pointed hat, offers comfort to the bereaved. The figures are simplified into patches of strong colour, loosely painted, but designed with clarity.

A version in ink (Birmingham City Museum and Art Gallery, fig. v) brings out the naïve and angular features of this linear style, which was current amongst members of the Brotherhood in the early years: similar qualities can be seen in Charles Collins's *The Pedlar* (13). Far from showing 'truth to nature', this style is very individual and mannered. It was partly deliberately so, meant as an affront to eyes accustomed to the mellifluous lines and sloppy definition of much contemporary academic painting. But it is also the result of an admiration for the linear style of Flaxman and Blake, and for the work of the Nazarenes and the German graphic artists who came after them.

But the most famous source, the one which gave the Brotherhood its name, is Italian art before Raphael. None of the brothers had been to Italy, but one evening in Millais' studio, they looked at a volume of Lasinio's engravings of the frescoes at the Campo Santo in Pisa. Though not a faithful rendering of the originals (Ruskin described Lasinio's work as execrable), the engravings gave a picture of early Italian art which emphasised wiry line, clear modelling, attention to detail, and clarity and sincerity of storytelling. In their early work the Pre-Raphaelites seized on these qualities with enthusiasm, and added to them a delight in bright and variegated colour.

Berengaria's alarm for the safety of her husband, Richard Cœur de Lion, awakened by the sight of his girdle offered for sale at Rome is the original, though rather cumbersome title of *The Pedlar* (13 + colour plate 1). In the Brotherhood, Collins was a follower and not a leader: his work owes much to Millais, who brought him into the circle. His style suddenly changed from academic dullness to Pre-Raphaelite sharpness and brightness, but his use of the mannered linear style has a static and lifeless quality, lacking the intensity and brilliance of Millais. Nevertheless, *The Pedlar* is an attractive picture: the main figures are clearly (perhaps too clearly) modelled

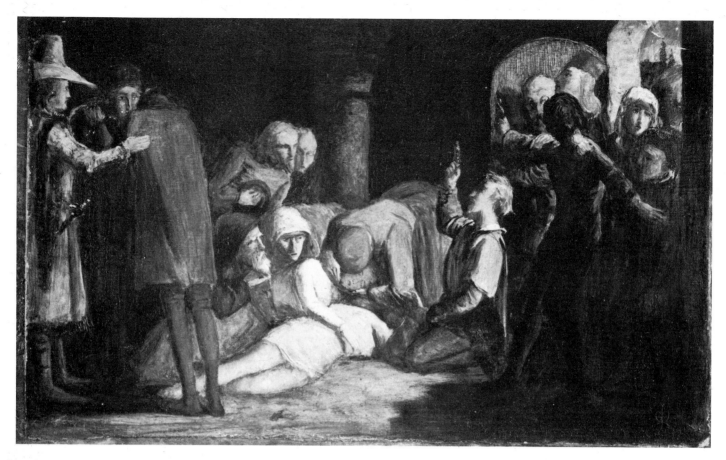

12
John Everett Millais:
The Death of Romeo and Juliet c. 1848

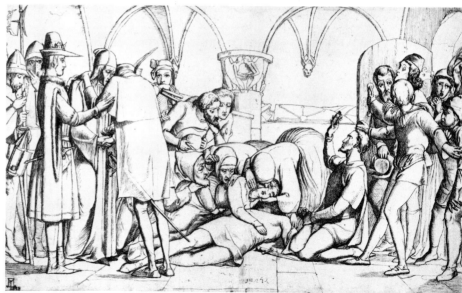

Fig. v
Sir John Everett Millais:
The Death of Romeo and Juliet, pen and ink

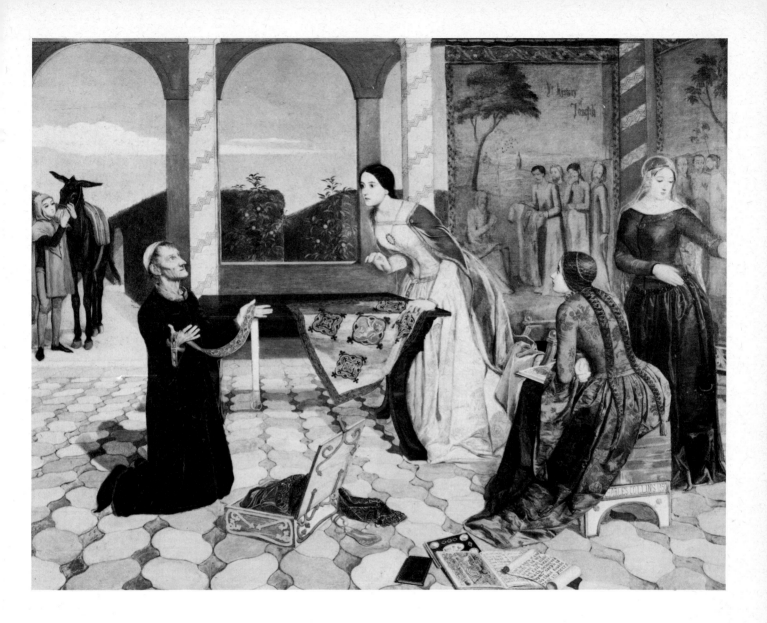

13
Charles Allston Collins:
Berengaria's alarm for the safety of her husband,
Richard Cœur de Lion, awakened by the sight of his
girdle offered for sale at Rome (formerly *The*
Pedlar) 1850

and highly finished, and the background is full of quaint details such as the artist's signature made to appear part of the stool, the tapestry of the story of Joseph, the scroll also referring to Joseph, the embroidery, and the illuminated manuscript of the Gospels. Joseph is included deliberately, for, like Richard Cœur de Lion, he was recognised in his absence by his clothing, and the story of Joseph and his brothers is sometimes thought to be a prefiguration in the Old Testament of the story of Christ in the New. Florentine art is recalled by Collins's playful interest in the perspective of the tiled floor, the arcade, and the hedges in the garden.

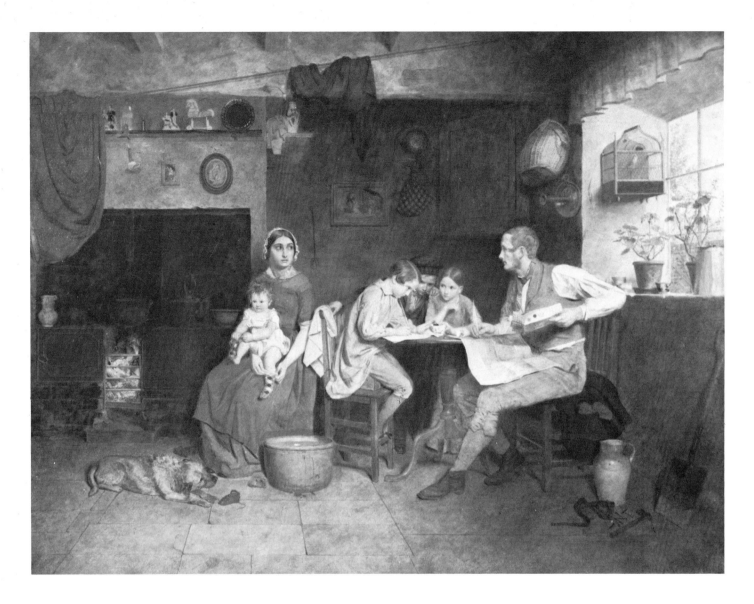

14
James Collinson:
Answering the emigrant's letter 1850

'Another instance of perversion is to be regretted in *Berengaria's Alarm for the Safety of her Husband*', wrote the *Athenaeum* art critic reviewing the Royal Academy of 1850, where Collins's picture was shown. His views are to be explained by the fact that a group of Pre-Raphaelite pictures on public display at this time had unleashed a storm of savage criticism. The pictures included Millais' *Christ in the House of his Parents* (Tate Gallery, London) and Hunt's *A Converted British Family Sheltering a Christian Priest from the Persecution of the Druids* (Ashmolean Museum, Oxford), both at the Royal Academy, and Rossetti's *Ecce Ancilla Domini* (Tate Gallery) at the National Institution. The critics, who

included Charles Dickens, were extreme in their abuse. They could not accept the angularities of style, and found the realism ugly and undignified. 'Their ambition is an unhealthy thirst which seeks notoriety by means of mere conceit. Abruptness, singularity, uncouthness, are the counters by which they play for game. Their trick is to defy the principles of beauty and the recognised axioms of taste.'

On the other hand, another Pre-Raphaelite painting at Manchester, shown at the same Royal Academy, serves to illustrate the diversity within the Brotherhood. At first sight, *Answering the emigrant's letter* (14) by James Collinson does not appear to be a Pre-Raphaelite work, for all its painstaking detail. Its conventional style would have been acceptable to the most conservative critics of the exhibition, for it belongs to a type of shadowy, picturesque cottage interior which goes back to Dutch seventeenth-century painting, and which had been revived and popularised by Wilkie in the early nineteenth.

But it is the first Pre-Raphaelite painting to draw its subject matter from urgent social problems of contemporary life, without disguising them in historic garb. Collinson shows a poor family in a cottage interior, and he has treated the furnishings and bric-a-brac with a miniaturist's touch: when William Michael Rossetti visited him in October 1848 he noted, 'He has done a considerable part of the window and its adjuncts, finishing up the trees outside to a pitch of the extremest minuteness, and he is advanced with the heads of the boy writing and the girl.'

It was skied at the Academy, so it is hardly surprising that the *Art Journal* commented, 'The question of correspondence is sufficiently evident, but it is impossible to determine that the family council is held on the subject of a letter to an emigrant.' The canvas has to be closely examined before the clues can be seen: the map is inscribed 'South Australia', and the father, holding the letter with tidings from the new life overseas, exchanges significant glances with his wife, who is holding a dishevelled baby. Meanwhile, the children concentrate on composing their reply.

Collinson was a fellow student of Hunt and Rossetti, and was in love with Christina Rossetti, the painter's sister. He hesitated between Anglicanism and Catholicism, finally choosing the latter: he resigned from the Brotherhood and broke off his engagement. He also hesitated between styles: whilst finishing off *The emigrant's letter* he 'made up his mind to cut the Wilkie style of Art for the Early Christian', and his next work was in the new mannered, archaic style.

Emigration was a topical subject in 1850; a mass movement of the poor and unemployed to the colonies was then at its height. Over one and a half million people left the United Kingdom between 1847 and 1852, and many took part in the Australian gold rush. The subject was frequently debated in Parliament, newspapers and pamphlets, and was often reflected in paintings and prints of the 1850s. The Pre-Raphaelite circle was directly affected in 1852 when the sculptor Thomas Woolner, a member of the Brotherhood, left for Australia, despairing of finding commissions at home. This suggested to Ford Madox Brown the idea for

William Holman Hunt:
Dante Gabriel Rossetti 1853

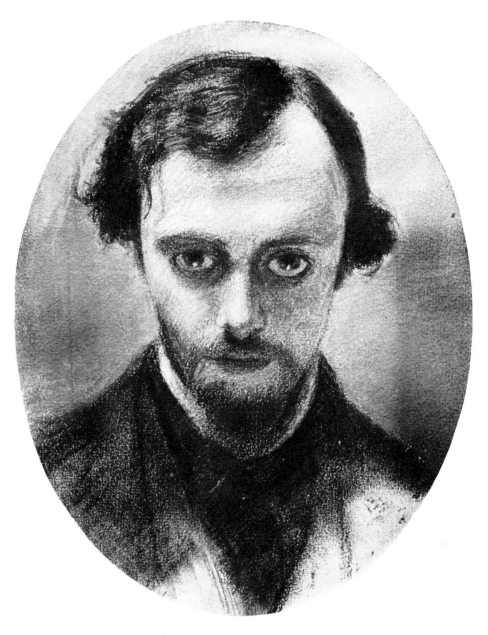

The Last of England (Birmingham Museums and Art Gallery) and also provided the occasion for the pastel drawing by Hunt of *Rossetti* (15). On April 12th, 1853 members of the Brotherhood met at Millais' studio and drew portraits of each other to send to Australia as mementoes for Woolner. Hunt's pastel vividly captures Rossetti's intense good looks: his large, luminous eyes gaze out hypnotically as he tilts his head forward, concentrating on his own drawing of Hunt (now at Birmingham Museums and Art Gallery).

Truth to nature

Hunt's painting *The Hireling Shepherd* (16 + in colour on front cover), exhibited at the Academy in 1852 but painted the previous year, shows a dazzling profusion of naturalistic detail quite different from any of the pictures yet discussed. It was begun out of doors at Worcester Park Farm, near Ewell in Surrey, where Hunt and Millais spent the summer of 1851 painting together. Both artists experimented with the technique of painting over a wet white ground, renewed daily, to achieve a sunlit brilliance of colour, and instead of wooden palettes they mixed their paints on porcelain tablets to ensure clarity.

Hunt worked at the surface of his painting most minutely, so that the fine details of flowers, foliage, blades of grass, clothing, hair, folds and wrinkles of skin were all depicted in sharp focus. According to a letter written by Hunt in 1897, in the collection of the City Art Gallery, 'My first object as an artist was to paint, not Dresden china bergers, but a real shepherd, and a real shepherdess, and a landscape in full sunlight, with all the colours of luscious summer, without the faintest fear of the precedents of any landscape painters who had rendered Nature before.' His picture falls into a well-established artistic tradition of flirtatious shepherds and shepherdesses, but rejects Rococo artificiality in favour of a modern realism which contemporaries found coarse and shocking. (The *Athenaeum* commented, 'He revels in the repulsive. These rustics are of the coarsest breed, ill-fed, ill-favoured, ill-wanted.') Hunt also avoided the pitfalls of the linear, archaic Pre-Raphaelite style, which he condemned as antiquarian and backward-looking, copying too literally the mannerisms of the early Italians.

But at the same time Hunt was concerned with contemporary relevance, and the painting can be appreciated on another level as a criticism of the church. Whilst painting, he read two recent pamphlets on the state of the Church, *Notes on the Construction of Sheepfolds* by Ruskin, and *Notes on Shepherds and Sheep* by Dyce. Both of these used the same pastoral imagery of the clergy as a shepherd and the parishioners as flock. Hunt took the title of his painting from St John:

'I am the good shepherd; the good shepherd giveth his life for the sheep.

But he that is an hireling, and not the shepherd, whose own the sheep are not, seeth the wolf coming, and leaveth the sheep and fleeth; and the wolf catcheth them, and scattereth the sheep.

The hireling fleeth because he is an hireling, and careth not for the sheep.'

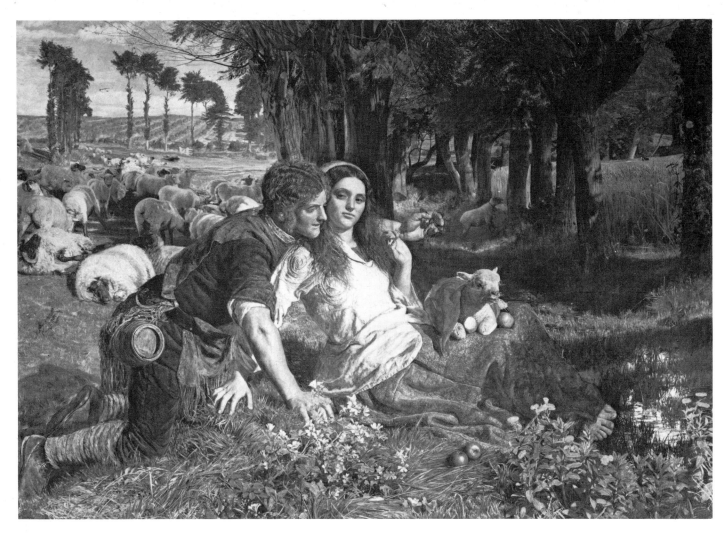

16
William Holman Hunt:
The Hireling Shepherd 1851

He also recalled the shepherd in a song from Shakespeare's *King Lear*, which he printed in the Academy exhibition catalogue:

'Sleepeth or waketh thou, jolly shepherd?
Thy sheep be in the corn;
And for one blast of thy minikin mouth,
Thy sheep shall take no harm.'

Hunt enlarged on this in the letter quoted above. 'Shakespeare's song represents a shepherd who is neglecting his real duty of guarding the sheep. Instead of using his voice in truthfully performing his duty, he is using his "minikin mouth" in some idle way. He was a type of other muddle-headed pastors, who, instead of performing their services to the flock – which is in constant peril – discuss vain questions of no value to any human soul. My fool has found a death's head moth,

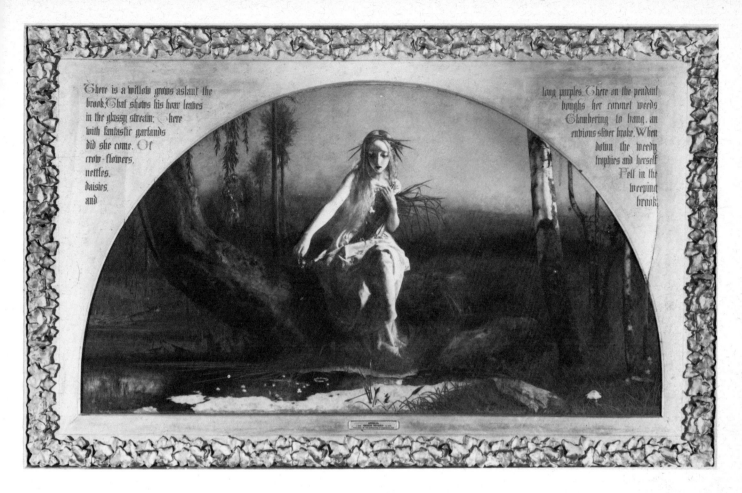

There is a willow grows aslant the brook, That shows his hoar leaves in the glassy stream: there with fantastic garlands did she come. Of crow-flowers, nettles, daisies, and

long purples. There on the pendant boughs her coronet weeds Clambering to hang, an envious sliver broke. When down the weedy trophies and herself Fell in the weeping brook.

17
Arthur Hughes:
Ophelia 1852

and this fills his little mind with forebodings of evil, and he takes it to an equally sage counsellor for her opinion. She scorns his anxiety from ignorance rather than profundity, but only the more distracts his faithfulness. While she feeds her lamb with sour apples, his sheep have burst bounds and got into the corn. It is not merely that the wheat will be spoilt; but in eating it the sheep are doomed to destruction from becoming what farmers call "blown".' Sheep can be glimpsed, straying into the radiant cornfield on the right, and others, bloated with what they have eaten, are lying on the grass at the left. The significance can be further extended as an allegory not just of the church's failure to look after its flock, but of man's neglect of his own spiritual nature.

But contemporary onlookers were principally struck with the vivid colour of the lush summer landscape and its uncanny sharpness and brightness, almost as artificial as the conventions Hunt was attacking. Modern eyes are used to bright colour and earthy subject matter, but *The Hireling Shepherd* still retains something of the jarring quality the picture had when first exhibited.

With Hunt at Ewell was Millais, working in equally minute detail on the background of his *Ophelia* (Tate Gallery). Both these were shown in the Academy of 1852, where, by complete coincidence, Arthur Hughes also showed an *Ophelia* (17 + colour plate II). Hughes had a conventional art training, but became a convert to Pre-Raphaelitism after reading *The Germ*, the magazine produced for a short time by the Pre-Raphaelite Brotherhood. Neither Hughes nor Millais knew about each other's picture until the varnishing day of the Academy. Hughes had obviously been impressed with the Pre-Raphaelite pictures exhibited in previous years: the harsh lighting and high finish of the figure is like that in Millais' earlier paintings, and the delicately-handled details of the mossy pool, the grasses, ivy, toadstools and flowers follow Pre-Raphaelite interests. But Hughes was less fanatical in his rendering of detail, and more stagy in setting and composition. Instead of covering the entire picture area in sharply-focused detail, Hughes treated only the foreground in this way, and left the space behind Ophelia misty and unclear. The intense, glowing colour scheme of purples and greens gives the picture its character, but is not strictly naturalistic. Nevertheless, Hughes's *Ophelia* is a hauntingly atmospheric image. The sense of beauty is emphasised by the frame into which his semi-circular canvas is set, decorated with a quotation from Shakespeare in gothic lettering and surrounded by a band of ivy, echoing that in the painting.

In the late summer of 1851, whilst at Worcester Park Farm, working on *The Hireling Shepherd*, Hunt began another painting, *The Light of the World* (Keble College, Oxford). This was not completed until 1853 and not shown until the 1854 Academy, by which time the artist was in the Holy Land. The Manchester version (18) began as Hunt's original oil sketch, and he turned it into a finished work after the main picture was complete: it is much smaller than the primary version and lacks its extremely high finish. (The third version at St Paul's Cathedral is a very late replica, painted around 1900 with the help of an assistant.)

As in the case of *The Hireling Shepherd*, Hunt went to tremendous lengths to imbue his religious image with realism. He found an overgrown door in the neighbourhood, and painted the background from the orchard of the farm. Here, to paint the moonlight effect, he worked out of doors night after night, and to keep the cold out, for winter was approaching, had a little hut built and sat with his feet in a bundle of straw. As a lamp was too dazzling, he painted by candlelight. One night Millais came out with him and held the lantern to demonstrate the effect of light shining on the face from below. Later he continued the painting in his London studio. He had a plaster model of the head made, but also used Christina Rossetti and Elizabeth Siddal for the colour and the hair. For the drapery he experimented with a linen tablecloth on a lay figure, and to finish the door he pinned up some ivy which he brought to town from Surrey. By day he screened out the light from his studio, and at night opened the blinds to admit the moonlight. He had a lantern specially made in brass to his own design, and different types of fuel had to be tried as it smoked, became red hot or went out.

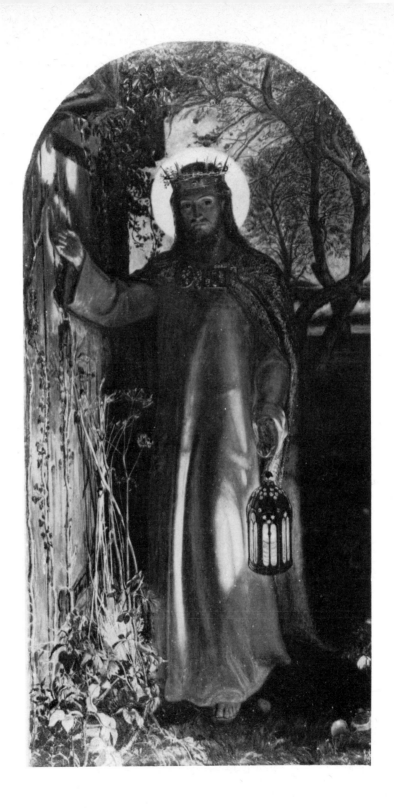

Hunt's painting was suggested by the text from Revelations:

'Behold, I stand at the door and knock: if any man hear my voice and open the door, I will come in to him and will sup with him, and he with me.'

But as before, Hunt wished to invent a new religious image and so developed his Biblical source. He set the scene at night so that Christ could be seen as bringing light to a dark world, and to give meaning to the door, he put rusty hinges on it, choked it up with weeds, and put it in a neglected orchard strewn with fruit. In a letter to *The Times*, defending Hunt from adverse criticism, Ruskin explained the symbolism further. 'Now when Christ enters a human heart, He bears with him a twofold light. First, the light of conscience, which displays past sin; and afterwards the light of peace, the hope of salvation. The lantern carried in Christ's left hand is this light of conscience. . . . The light which proceeds from the head of the figure, on the contrary, is that of the hope of salvation . . . I think it one of the very noblest works of sacred art ever produced in this or any other age. . . .'

Unlike *The Hireling Sheperd*, which could be read simply as a naturalistic scene, *The Light of the World* has a supernatural element which prevents it from being a real man knocking at a real door. 'Do you ever suppose that Jesus walked about bedizened in priestly robes and a crown, and with yon jewels on his breast, and a gilt aureole round his head?' asked Thomas Carlyle. The halo casts an unnatural light, contrasting with the carefully studied lantern-light, and is surprising in view of Hunt's dismissive criticism of Rossetti's religious pictures as 'church traditional work with gilt aureoles and the conventionalisms of early priesthood which we did away with at the Reformation.' Nevertheless, Hunt succeeded in inventing a new image of Christ which became as well known as the traditional ways of representing him.

The Brotherhood dissolves

'The P.R.B. is in its decadence:
For Woolner in Australia cooks his chops,
And Hunt is yearning for the land of Cheops;
D.G. Rossetti shuns the vulgar optic;
While William M. Rossetti merely lops
His B's in English disesteemed as Coptic;
Calm Stephens in the twilight smokes his pipe,
But long the dawning of his public day;
And he at last the champion great Millais,
Attaining academic opulence,
Winds up his signature with A.R.A.
So rivers merge in the perpetual sea;
So luscious fruit must fall when over-ripe;
And so the consummated P.R.B.'

Christina Rossetti's sonnet of 1853 reflects the drifting apart of the Brotherhood. In the early days, when each new discovery had been shared with enthusiasm, there seemed to be a common purpose, and something of common style was evolved, hard, linear, angular and brightly coloured. But with time, the young aspirants matured and discovered their own individual styles. Quite early on, William Michael Rossetti and Frederic Stephens decided they could not paint at all, and became writers on art, the chief apologists and historians of the Brotherhood. Woolner left for Australia (he came back in 1854), and Collinson resigned. Millais, the former infant prodigy, accepted the Associateship of the Royal Academy, the institution which the Pre-Raphaelite Brotherhood had sought to attack. Rossetti and Hunt, on the other hand, remained doggedly anti-establishment, but found themselves pursuing opposite directions, the former working from the archaic, imaginative tendency of Pre-Raphaelitism, and the latter developing its naturalistic side.

Rossetti had by the mid 1850s taken almost exclusively to drawing, and had forsaken painting from nature in favour of subjects drawn from the imagination. His two major early oil paintings (*The Girlhood of Mary* and *Ecce Ancilla Domini*, both Tate Gallery) had employed the archaic, detailed, brightly coloured style, and despite a certain stiffness, they had strong expressive power. But his next

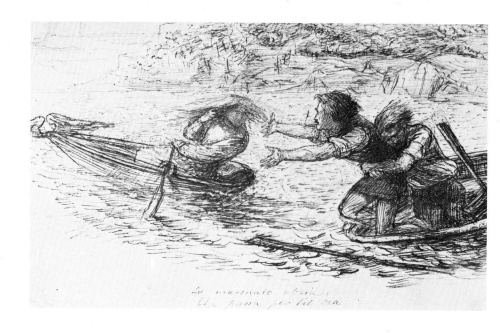

major attempt at oil painting, *Found* (Delaware Art Museum), remained unfinished all his life. *Found* was Rossetti's attempt at a modern life subject, treated with naturalism and with fine detail. It showed a prostitute recognised at dawn on the streets of London by her former lover, a country drover coming to market. Such a set piece demanded persistence, planning and meticulous technique, but Rossetti was unable to cope with the problems of detail and perspective, and found oil difficult to handle. He preferred the more immediate process of drawing, using watercolour, pencil, crayon, pastel or ink to set down his thoughts on paper with great freedom. He developed a personal kind of expressive stylisation, highly unorthodox (and it should be remembered that being unorthodox was one of the original tenets of the Brotherhood). His subject-matter too was unusual and was closely related to his own poetry, his interests in other writers, and his personal, often obsessive relationships with women.

Boatmen and siren (19) is an ink drawing in a somewhat unusual style, which conveys swift movement and intense passion. A boatman is restraining his companion from being lured to death by the siren whose hair streams out in the wind as her boat speeds by. The inscription, 'Lo marinaio oblia, Che passa per tal via', comes from a *canzone* by the Italian Renaissance poet Jacopo da Lentino.

> 'I am broken as a ship
> Perishing of the song
> Sweet, sweet and long, the song the sirens know.
> The mariner forgets,
> Voyaging in those straits,
> And dies assuredly.'

20
Dante Gabriel Rossetti:
Dante meeting Beatrice 1864

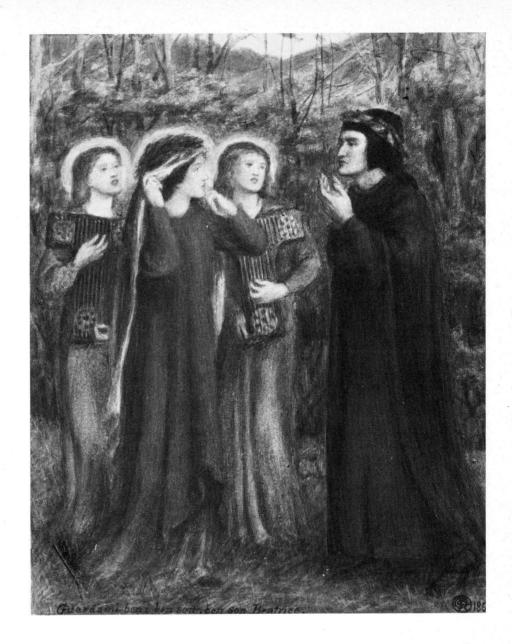

The translation is by Rossetti himself, who was an avid reader of Italian poetry, particularly that of Dante, who inspired much of his early work. Rossetti's father was a famous Dante scholar, which is why he christened his son after his hero. The painter took an obsessive interest in his namesake, to the extent of identifying with him and particularly with his mystical relationship with Beatrice.

In 1853 he painted *Dante meeting Beatrice in Paradise* (Fitzwilliam Museum, Cambridge), and Manchester has a version of this (20). Rossetti described it and its

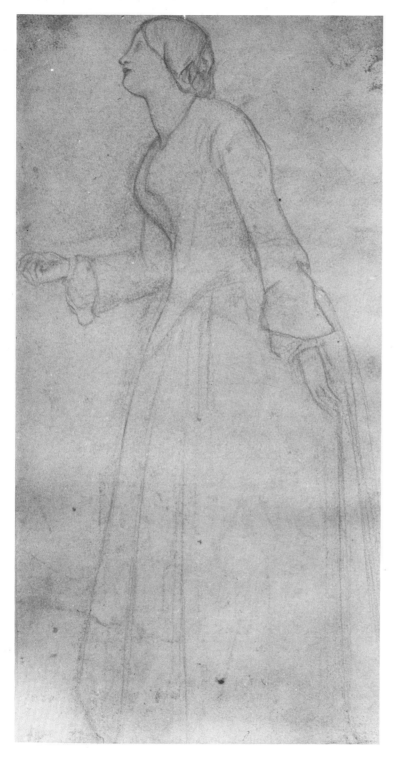
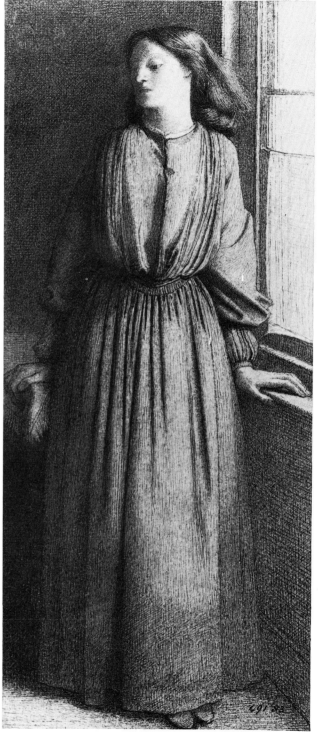

Italian inscription in a letter to Gambart, the picture dealer. 'The second subject is Dante's meeting with Beatrice in Eden, after her death as described by him in the 30th Canto of the second part of the *Divina Commedia*. "With a white veil and a wreath of olive, a lady appeared to me wearing a green mantle over a dress of the colour of living flame." The line underneath is what she says to him: "Look on me well; I indeed, I indeed am Beatrice." In the picture, Dante is intended to have just raised his face from his hands in which he has hidden it, to look at Beatrice when she unveils.' Dante and Beatrice gaze at each other intensely, against the measured rhythm of the two angels with musical instruments, mirroring each other. The strong feeling of emotion is heightened by the softly glowing greens and blues of the pastel.

Rossetti's use of colour is well illustrated by a letter, written in 1850 whilst he and Hunt were painting landscapes in the open air. 'The fact is, between you and me, that the leaves on the trees I have to paint here appear red, yellow, etc. to my eyes; and as of course I know them on that account to be really of a vivid green, it seems rather annoying that I cannot do them so: my subject shrieking aloud for Spring.' At the time, Rossetti was working on a landscape in Sevenoaks which he left incomplete; it was taken up over twenty years later and incorporated into *The bower meadow* (70). But it shows how he chose the colour, not to depict what he could see in front of him, as with Hunt, but for its expressive mood, and its symbolic associations.

As Beatrice was Dante's muse, so was *Elizabeth Siddal* (21 + fig. vi) that of Rossetti. She was introduced to the Pre-Raphaelite Brotherhood in 1849 or 1850 by Walter Deverell, the painter. He found her working in a milliner's shop, and asked her to model for him. She posed for other members, but gradually was monopolized by Rossetti: despite his relationships with other women, her features are seen consistently in his work of the 1850s, as the Virgin, as Ophelia, as Arthurian heroines, as Beatrice. She was physically weak, and constantly in ill health. The couple did not marry until 1860, and she died soon afterwards in 1862.

Rossetti's nickname for her was 'Guggums', but in the many wonderful drawings of her, she appears as anything but babyish: waiflike, withdrawn, and meditative. Brown noted in 1854, 'Miss Siddal, looking thinner and more deathlike and more ragged than ever,' and noted Rossetti, 'drawing wonderful and lovely Guggums one after another, each one a fresh charm, each one stamped with immortality.' In 1855 Rossetti showed Brown, 'a drawer full of "Guggums", God knows how many ... it is like a monomania with him.' Seen on its own, Manchester's pencil drawing is delicate enough, but it takes its place in a series which as a whole is intensely moving and beautiful.

Less passionately felt, but equally poetic and beautiful, are Millais' paintings of women. The tiny *Wandering thoughts* (22) shows a woman musing over the contents of a letter, her black dress hinting perhaps at a bereavement. Ford Madox Brown described it as 'a noble study of Millais, [of] an ugly girl in black receiving bad news.' The slightly later *Only a lock of hair* (23) shows a young woman in the act of

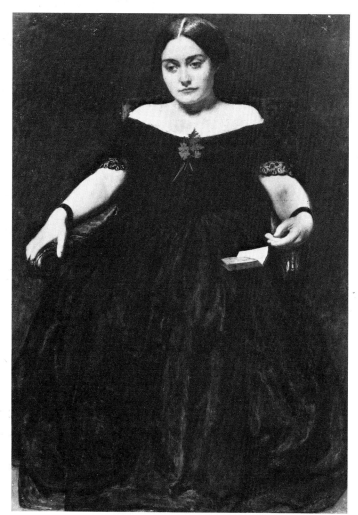

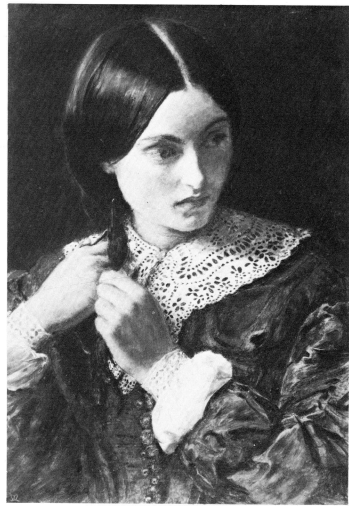

22
John Everett Millais:
Wandering thoughts c. 1855

23
John Everett Millais:
Only a lock of hair c. 1857–8

cutting off a strand of hair with a pair of scissors: the title and her thoughtful expression also suggest speculation over events outside the picture. These paintings are not quite portraits, nor are they genre subjects: Millais has imbued them with an evocative quality, turning prose into poetry.

Of the Pre-Raphaelites, Millais was technically most at ease with his medium. Beautiful effects seemed to come effortlessly, without struggle, and so he was prepared to sacrifice extreme Pre-Raphaelite principles for the sake of beauty. In these two pictures, his eye for fine detail was employed selectively, without accumulation of minutiae, and his colour schemes, the one sombre, the other golden, were chosen for poetic effect rather than naturalism. But the important passages, such as the faces, were treated in a way which owed everything to Pre-Raphaelite intensity and truth to nature.

Autumn leaves (24 + colour plate III) is Millais' finest work of this type. 'He wished to paint a picture full of beauty and without subject', wrote his wife Effie, and Ford Madox Brown called it, 'the finest in painting and colour he has yet done, but the subject somewhat without purpose and looking like portraits'. It is not a dense and factual image with a message, such as Hunt or Brown might paint, but rather an evocation of mood. Hunt quotes a remark made by Millais in 1851, some years before he painted *Autumn leaves*, which may have suggested the idea: 'Is there any sensation more delicious than that awakened by the odour of burning leaves? To me nothing brings back sweeter memories of the days that are gone; it is the incense offered by departing summer to the sky; and it brings one a happy conviction that time puts a peaceful seal on all that is gone.' Millais also knew the lines from Tennyson's poem *The Princess*:

'Tears idle tears, I know not what they mean,
Tears from the depth of some divine despair
Rise in the heart, and gather to the eyes,
In looking on the happy Autumn-fields,
And thinking of the days that are no more.'

Millais painted *Autumn leaves* in 1865 in the garden of Annat Lodge, near Bowerswell, Perthshire, the house where he and his wife settled in 1855, shortly after their marriage. His wife's sisters Sophie and Alice modelled for two of the girls, and his wife enthusiastically recorded the mundane details of the work in her diary. 'He immediately began to paint on the Canvass he had commenced Sophie on. In two or three days he was in high spirits and much delighted with the rapidity of his execution. In the background he had put to her head, seizing the moment immediately after sundown, he painted [the] horizon behind Perth, the distant Peak of Ben Vorlich, the Golden sky, the town lost in mist and the tall Poplar trees just losing their leaves. Later he softened it and brought the background into better colour, still magnificently bright. In the lower part of the background he put our lawn and the Apple trees at the foot of the garden, in the front four figures aurified with a Bonfire of Autumn leaves from which smoke issued. The figures were Sophie, Alice, Matilda Proudfoot, a girl from the School of Industry, and Isabella Nicol, a little girl from Low Bridgend. All the girls were under 13 years of age and grouped beautiful[ly]. Sophie in the middle is holding a bunch of leaves which are dropping into the Basket; Alice is holding it with both hands. It is a large common garden wicker basket. Both the girls are in their winter dresses of green linsey Wolsey their hair unbound hanging over their shoulders, little frills round their necks and stout walking boots. Matilda is standing with her face half round leaning on a rake or broom for gathering the leaves in a browning [word illegible] cotton dress and cape, the common dress of the School of Industry at that season, her brilliantly red hair glowing against the background of Hills of dark blue. Little Isabella on her side was in purple with her hair plaited at night combed straight out in the morning and dressed in Linsey Wolsey purple with a scarlet neck tie, a couple of gentianellas in one hand, and an Apple in the other.'

24
John Everett Millais:
Autumn leaves 1856

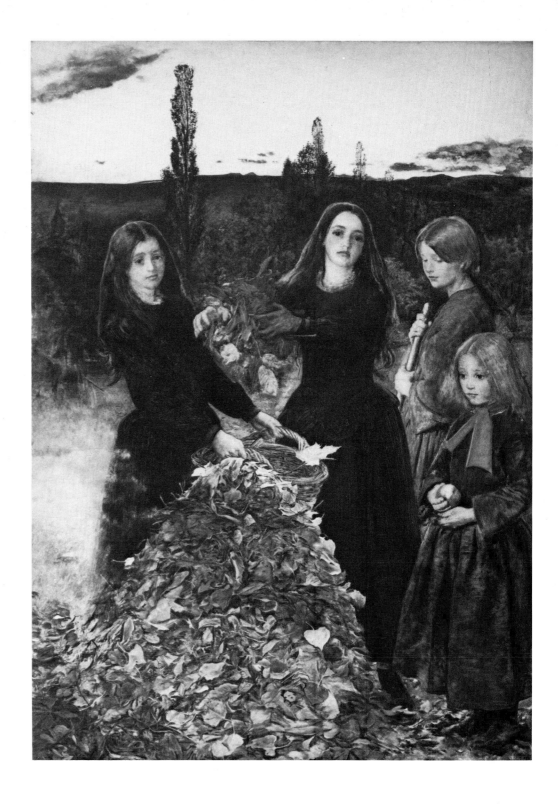

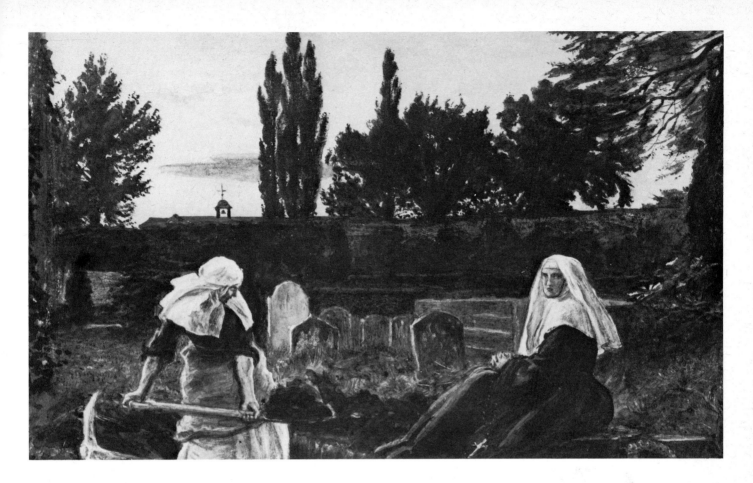

25
John Everett Millais:
Study for 'The Vale of Rest' c. 1858

Pre-Raphaelite naturalism has softened slightly: the leaves are not as fine as the greenery in Millais' *Ophelia* (Tate Gallery), the distance in soft focus, and the loosely sketched figure of the gardener on the left, in the background, are hardly defined at all. Nevertheless, Millais has skilfully evoked the atmosphere of autumn, the evening sky, the smoke, the rich brown and gold of the leaves and the wistful faces of the girls. Ruskin, recognising both the haunting quality of the idea and the Pre-Raphaelite observation of nature, thought it, 'by much the most poetical work the artist has yet conceived; and also, as far as I know, the first instance of a perfectly painted twilight. It is easy, as it is common, to give obscurity to twilight, but to give the glow within the darkness is another matter; and though Giorgione might have come nearer the glow, he never gave the valley mist. Note also the subtle difference between the purple of the nearer range of hills and the blue of the distant peak.'

In 1858, Mrs Millais' diary describes another work painted at Bowerswell. 'Being greatly impressed with the beauty of the sunset, he rushed for a large canvas, and began at once upon it, taking for the background the wall of our

garden at Bowerswell, with the tall oaks and poplar trees behind it. The sunsets were lovely for two or three nights, and he dashed the work in, softening it afterwards in the house, making it, I thought, even less purple and gold than he saw it in the sky. The effect lasted so short a time that he had to paint like lightning.' This was *The Vale of Rest* (Tate Gallery), of which Manchester has a small version in watercolour (25). The *Autumn leaves* ingredients of trees silhouetted against the sunset, and a girl gazing straight out of the picture are used again: but the girl has become a nun, and the suggestion of death and sadness has lost its subtlety. A second nun is shovelling earth into a grave, a church bell is outlined against the sky, and the coffin-shaped cloud is, according to Scottish superstition, a foreboding of death.

The oil, larger and less fine in execution than *Autumn leaves*, was criticized as 'frightful' when shown at the Academy in 1859. Ruskin found it powerful but crude, both in handling and in feeling. 'Why so frightful?' he wrote. 'Is it not because it is so nearly beautiful? Because the dark green field and windless trees, and purple sky might be so lovely to persons unconcerned about their graves?' He regarded it as a 'decline from the artist's earlier ways of labour.'

26
Ford Madox Brown:
Jesus washing Peter's feet 1876

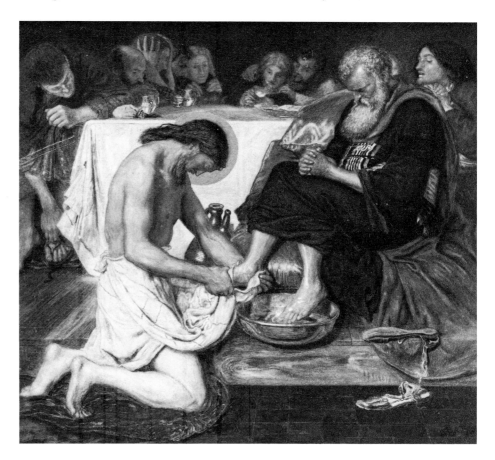

Ford Madox Brown:
The Pre-Raphaelite Period

In 1852 Brown made an oil painting of *Jesus washing Peter's feet* (Tate Gallery). According to St John's Gospel, after the Last Supper Jesus knelt down before each of his disciples and washed their feet, including those of Peter, who asked incredulously, 'Lord, dost thou wash my feet?' and again, 'Thou shalt never wash my feet.' 'The purposely assumed humility of Jesus at this moment, and the intense veneration implied in the words of Peter, I have endeavoured to render in this composition,' wrote Brown. Brown had read the text closely, for Jesus 'laid aside his garments', and so was shown naked to the waist. He is also wiping the feet 'with the towel wherewith he was girded'.

The picture was skied at the Academy of 1852, and heavily criticised. Brown only showed once more at the Academy, and sent work to the provinces where it was better appreciated. At the Liverpool Academy of 1856 *Jesus washing Peter's feet* won a £50 prize, and it also attracted attention at the famous Manchester Art Treasures exhibition of 1857. But in the meantime Brown had bowed to public taste, and painted clothing over Jesus's figure.

In the Manchester version (26) Jesus is half-naked as in the original design. But this is a replica, painted by Brown much later, in 1876, for Charles Rowley, a Manchester patron (see p. 119).

Humility and sympathy with the humble were amongst Brown's strongest convictions. They are amply demonstrated in *Work* (27 + colour plate IV), begun in 1852. Brown had the idea for the picture after seeing a group of navvies excavating sewers in Heath Street, Hampstead, and much of the painting was done on the spot in the open air. But he peopled Heath Street with an assemblage of deliberately chosen types: for all its minute naturalism, its realistic light and sunny colour, *Work* is a symbolic tract, celebrating those facets of society founded on honest toil, and demonstrating the ill effects of lack of work, whether from unfortunate poverty or from riches. The biblical quotations on the frame underline the message, 'In the sweat of thy face shalt thou eat bread', and 'Seest thou a man diligent in his business? He shall stand before Kings.'

Brown's own description is worth quoting in full, despite its length. He wrote it for an exhibition of his pictures in 1865.

'This picture, on account of which, in a great measure the present exhibition has been organised, was begun in 1852 at Hampstead. The background, which

represents the main street of that suburb not far from the heath, was painted on the spot.

'At that time extensive excavations, connected with the supply of water, were going on in the neighbourhood, and seeing and studying daily as I did the British excavator, or *navvy*, as he designates himself, in the full swing of his activity (with his manly and picturesque costume, and with the rich glow of colour, which exercise under a hot sun will impart), it appeared to me that he was at least as worthy of the powers of an English painter, as the fisherman of the Adriatic, the peasant of the Campagna, or the Neopolitan lazzarone. Gradually this idea developed itself into that of "Work" as it now exists, with the British excavator for a central group, as the outward and visible type of *Work*. Here are presented the young navvy in the pride of manly health and beauty; the strong fully developed navvy who does his work and loves his beer; the selfish old bachelor navvy, stout of limb, and perhaps a trifle tough in those regions where compassion is said to reside; the navvy of strong animal nature, who, but that he was, when young, taught to work at useful work, might even now be working at the useless crank. Then Paddy with his larry and his pipe in his mouth.

'The young navvy who occupies the place of hero in this group, and in the picture, stands on what is termed a landing-stage, a platform placed half-way down the trench; two men from beneath shovel the earth up to him, and he shovels it on to the pile outside.

'Next in value of significance to these, is the ragged wretch who has never been *taught* to *work*; with his restless gleaming eyes, he doubts and despairs of every one. But for a certain effeminate gentleness of disposition and a love of nature, he might have been a burglar! He lives in Flower and Dean Street, where the policemen walk two and two, and the worst cut-throats surround him, but he is harmless; and before the dawn you may see him miles out in the country, collecting his wild weeds and singular plants to awaken interest, and perhaps find a purchaser in some sprouting botanist. When exhausted he will return to his den, his creel of flowers then rests in an open court-yard, the thoroughfare for the crowded inmates of this haunt of vice, and played in by mischievous boys, yet the basket rarely gets interfered with, unless through the unconscious lurch of some drunkard. The bread-winning implements are sacred with the very poor.

'In the very opposite scale from the man who can't work, at the further corner of the picture, are two men who appear as having nothing to do. These are the brainworkers, who, seeming to be idle, work, and are the cause of well-ordained work and happiness in others. Sages, such as in ancient Greece, published their opinions in the market square. Perhaps one of these may already, before he or others know it, have moulded a nation to his pattern, converted a hitherto combative race to obstinate passivity; with a word may have centupled the tide of emigration, with another, have quenched the political passions of both factions – may have reversed men's notions upon criminals, upon slavery, upon many things, and still be walking about little known to some. The other, in friendly

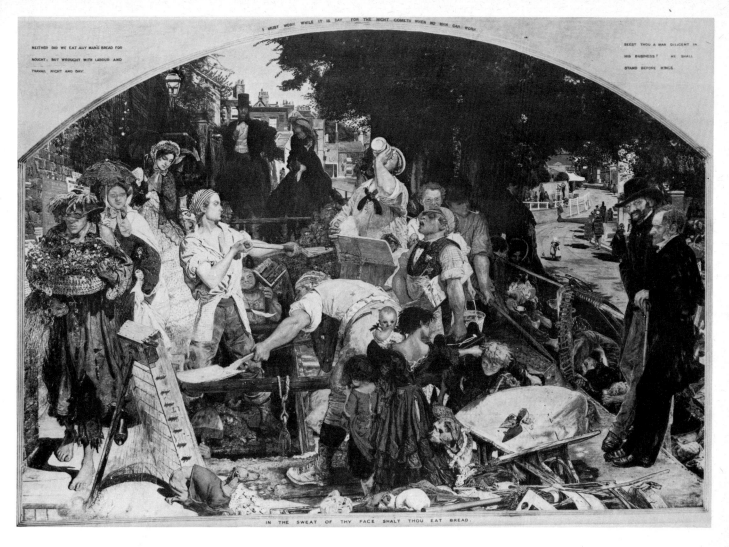

I MUST WORK WHILE IT IS DAY FOR THE NIGHT COMETH WHEN NO MAN CAN WORK

NEITHER DID WE EAT ANY MAN'S BREAD FOR
NOUGHT; BUT WROUGHT WITH LABOUR AND
TRAVAIL NIGHT AND DAY.

SEEST THOU A MAN DILIGENT IN
HIS BUSINESS? HE SHALL
STAND BEFORE KINGS.

IN THE SWEAT OF THY FACE SHALT THOU EAT BREAD.

27
Ford Madox Brown:
Work 1852–65

communion with the philosopher, smiling perhaps at some of his wild sallies and cynical thrusts (for Socrates at times strangely disturbs the seriousness of his auditory by the mercilessness of his jokes – against vice and foolishness), is intended for a kindred and yet very dissimilar spirit. A clergyman, such as the Church of England offers examples of – a priest without guile – a gentleman without pride, much in communion with the working classes, "honouring all men", "never weary in well-doing." Scholar, author, philosopher, and teacher, too, in his way, but not above practical efforts, if even for a small result in good. Deeply penetrated as he is with the axiom that each unit of humanity feels as much as all the rest combined, and impulsive and hopeful in nature, so that the remedy suggests itself to him concurrently with the evil.

'Next to these, on the shaded bank, are different characters out of work, haymakers in quest of employment; a stoic from the Emerald Island, with hay stuffed in his hat to keep the draught out, and need for his stoicism just at present, being short of baccy – a young shoeless Irishman, with his wife, feeding their first-born with cold pap – an old sailor turned haymaker, and two young peasants in search of harvest work, reduced in strength, perhaps by fever – possibly by famine.

'Behind the Pariah, who never has learned to work, appears a group, of a very different class, who, from an opposite cause, have perhaps not been sufficiently used to work either. These are the *rich*, who have no need to work – not at least for bread – *the "bread of life"* being neither here nor there. The pastry-cook's tray the symbol of superfluity, accompanies these. It is peculiarly English: I never saw it abroad that I remember, though something of the kind must be used. For some years after returning to England I could never quite get over a certain socialistic twinge on seeing it pass, unreasonable as the feeling may have been. Past the pastry-cook's tray come two married ladies. The elder and more serious of the two devotes her energies to tract distributing, and has just flung one entitled, "The Hodman's Haven, or drink for thirsty souls", to the somewhat unpromising specimen of navvy humanity descending the ladder: he scorns it, but with good nature. This well-intentioned lady has, perhaps, never reflected that excavators may have notions to the effect that ladies might be benefited by receiving tracts containing navvies' ideas! nor yet that excavators are skilled workmen, shrewd thinkers chiefly, and, in general, men of great experience in life, as life presents itself to them.

'In front of her is the lady whose only business in life as yet is to dress and look beautiful for our benefit. She probably possesses everything that can give enjoyment to life; how then can she but enjoy the passing moment, and like a flower feed on the light of the sun? Would anyone wish it otherwise? – Certainly, not I, dear lady. Only in your own interest, seeing that certain blessings cannot be insured for ever – as for instance, health may fail, beauty fade, pleasures through repetition pall – I will not hint at the greater calamities to which flesh is heir – seeing all this, were you less engaged watching that exceedingly beautiful tiny greyhound in a red jacket that *will* run through that lime, I would beg to call your attention to my group of small, exceedingly ragged, dirty children in the foreground of my picture, where you are about to pass. I would, if permitted, observe that, though at first they may appear just such a group of ragged dirty brats as anywhere get in the way and make a noise, yet, being considered attentively, they like insects, molluscs, miniature plants, &c., develop qualities to form a most interesting study, and occupy the mind at times when all else might fail to attract. That they are motherless, the baby's black ribbons and their extreme dilapidation indicate, making them all the more worthy of consideration, a mother, however destitute, would scarcely leave the eldest one in such a plight. As to the father, I have no doubt he drinks, and will be sentenced in the police-court

for neglecting them. The eldest girl, not more than ten, poor child! is very worn-looking and thin, her frock, evidently the compassionate gift of some grown-up person, she has neither the art nor the means to adapt to her own diminutive proportions – she is fearfully untidy therefore, and her way of wrenching her brother's hair looks vixenish and against her. But then a germ or rudiment of good housewifery seems to pierce through her disordered envelope, for the younger ones are taken care of, and nestle to her as to a mother – the sunburnt baby, which looks wonderfully solemn and intellectual as all babies do, as I have no doubt your own little cherub looks at this moment asleep in its charming basinet, is fat and well-to-do, it has even been put into poor mourning for mother. The other little one, though it sucks a piece of carrot in lieu of a sugar-plum, and is shoeless, seems healthy and happy, watching the workmen. The care of the two little ones is an anxious charge for the elder girl, and she has become a premature scold through having to manage that *boy* – that boy, though a merry, good-natured-looking young Bohemian, is evidently the plague of her life, as boys always are. Even now he *will* not leave that workman's barrow alone, and gets his hair well-pulled, as is natural. The dog which accompanies them is evidently of the same outcast sort as themselves. The having to do battle for his existence in a hard world has soured his temper, and he frequently fights, as by his torn ear you may know; but the poor children may do as they like with him, rugged democrat as he is, he is gentle to them, only he hates minions of aristocracy in red jackets. The old bachelor navvy's small valuable bull-pup, also instinctively distrusts outlandish-looking dogs in jackets.

'The couple on horseback in the middle distance, consists of a gentleman, still young, and his daughter. (The rich and the poor both marry early, only those of moderate incomes procrastinate.) This gentleman is evidently very rich, probably a Colonel in the army, with a seat in Parliament, and fifteen thousand a-year, and a pack of hounds. He is not an over-dressed man of the tailor's dummy sort – he does not put his fortune on his back, he is too rich for that; moreover, he looks to me an honest true-hearted gentleman (he was painted from one I know), and could he only be got to hear what the two sages in the corner have to say, I have no doubt

he would be easily won over. But the road is blocked, and the daughter says we must go back, papa, round the other way.

'The man with the beer-tray, calling beer ho! so lustily, is a specimen of town pluck and energy contrasted with country thews and sinews. He is humpbacked, dwarfish, and in all matters of taste, vulgar as Birmingham can make him look in the 19th century. As a child he was probably starved, stunted with gin, and suffered to get run over. But energy has brought him through to be a prosperous beer-man, and "very much respected," and in his way he also is a sort of hero; that black eye was got probably doing the police of his master's establishment, and in an encounter with some huge ruffian whom he has conquered in fight, and hurled out through the swing-doors of the palace of gin prone on the pavement. On the wall are posters and bills; one of the "Boy's Home, 41, Euston Road," which the lady who is giving tracts will no doubt subscribe to presently and place the urchin playing with the barrow in; one of "the Working Men's College, Great Ormond Street," or if you object to these, then a police bill offering £50 reward in a matter of highway robbery. Back in the distance we see the Assembly-room of the "Flamstead Institute of Arts", where Professor Snoöx is about to repeat his interesting lecture on the habits of the domestic cat. Indignant pusses up on the roof are denying his theory in toto.

'The less important characters in the background require little comment. Bobus, our old friend, "the sausage-maker of Houndsditch", from *Past and Present*, having secured a colossal fortune (he boasts of it *now*), by anticipating the French Hippophage Society in the introduction of horse flesh as a *cheap* article of human food, is at present going in for the county of Middlesex, and, true to his old tactics, has hired all the idlers in the neighbourhood to carry his boards. These being one too many for the bearers, an old woman has volunteered to carry the one in excess.

The episode of the policeman who has caught an orange-girl in the heinous offence of resting her basket on a post, and who himself administers justice in the shape of a push, that sends her fruit all over the road, is one of common occurrence, or used to be – perhaps the police now "never do such things."

'I am sorry to say that most of my friends, on examining this part of my picture, have laughed over it as a good joke. Only two men saw the circumstance in a different light, one of them was the young Irishman, who feeds his infant with pap. Pointing to it with his thumb, his mouth quivering at the reminiscence, he said, "that, Sir, *I* know to be true." The other was a clergyman, his testimony would perhaps have more weight. I dedicate this portion of the work to the Commissioners of Police.

'Through this picture I have gained some experience of the navvy class, and I have usually found, that if you can break through the upper crust of *mauvaise honte*, which surrounds them in common with most Englishmen, and which, in the case of the navvies, I believe to be the cause of much of their bad language, you will find them serious intelligent men, and with much to interest in their

conversation, which, moreover, contains about the same amount of morality and sentiment that is commonly found among men in the active and hazardous walks of life; for that their career is one of hazard and danger, none should doubt. Many stories might be told of navvies' daring and endurance, were this the place for them. One incident peculiarly connected with this picture is the melancholy fact, that one of the very men who sat for it lost his life by a scaffold accident, before I had yet quite done with him. I remember the poor fellow telling me, among other things, how he never but once felt nervous with his work, and this was, having to trundle barrows of earth over a plank-line crossing a rapid river at a height of *eighty feet* above the water. But it was not the height he complained of, it was the *gliding motion of the water underneath*.

'I have only to observe in conclusion, that the effect of hot July sunlight attempted in this picture, has been introduced, because it seems peculiarly fitted to display work in all its severity, and not from any predilection for this kind of light over any other. Subjects, according to their nature, require different effects of light.'

The moralistic contrasts of industry and idleness recall Hogarth, an artist much admired by Brown. But the naturalism, and the humanity with which Brown treats his theme makes his sermon compellingly vivid and alive, full of real people rather than mere symbols: it is full of touches of humour, such as the cats on the rooftop, the natty shirt-front and waistcoat of the beer seller, and the dogs, the poor girl's mongrel, the navvy's pug and the rich lady's sleek greyhound.

Brown was passionately involved with certain intellectual and social ideas of the day which inspired the painting: the two thinkers included as 'brainworkers' stand for these ideas. They are Thomas Carlyle (with hat and stick) and the Rev. Frederick Denison Maurice. Carlyle's book, *Past and Present*, which Brown read with enthusiasm, marking his favourite passages, was an indictment of a society dominated by Mammonism: 'money!! money!! money!!' is one of the grafitti on the wall. Carlyle felt that employers and rulers should have more responsibility to men than simply to pay their wages. 'We have profoundly forgotten everywhere that cash-payment is not the sole relation of human beings.' 'All work, even cotton-spinning, is noble,' and, 'there is a perennial sacredness in Work . . . there is always hope in a man that actually and earnestly works: in Idleness alone is there perpetual despair.' 'All true Work is Religion . . . "Laborare est Orare", Work is Worship.' So that men digging a ditch were of as much value to society as the heroic men of action or hero-thinkers: 'the proper Epic of this world is not now "Arms and the Man"; how much less "Shirt-frills and the Man"; no, it is now "Tools and the Man".'

The Rev. Frederick Denison Maurice, at Carlyle's side, founded the Christian Socialist party, which attempted to promote small profit-sharing workers' co-operatives. When this failed he started the Working Men's College in 1854, a body which was a pioneer in adult education, providing adults with classes in liberal, non-technical subjects. Amongst those who taught there were Ruskin, Rossetti

28
Ford Madox Brown:
Heath Street, Hampstead
(Study for 'Work') 1852–5

29
Ford Madox Brown:
First rough sketch for 'Work' · 1856

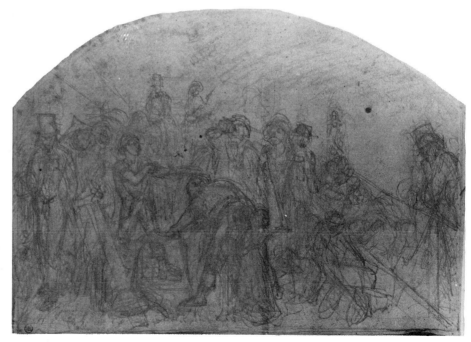

and Brown himself, who advertised its activities in the poster on the wall at the left of his painting.

Through the wealth of detail, Brown has demonstrated his own industriousness as well as those of his protagonists. The painting occupied him for a long time and required an immense amount of struggle and work: this in itself had a moral importance to him. He began it in 1852, when he painted the small oil sketch of *Heath Street, Hampstead* (28). This was done on the spot. He then began on the full-sized canvas and painted the background, also on the spot, working in a truck, much to the amusement of passers-by.

For a time the picture was laid aside for other work. According to Brown's diary, the central figure group was being designed in 1855, and there are two drawings in the collection showing different stages in the working out of the composition, a sketchy pencil drawing inscribed *First rough sketch for 'Work'* (29) and a highly finished *Preliminary study for 'Work'* (30) in watercolour. This was probably based on sketches of around this time or even earlier, but was not coloured until 1864, by which time the main oil was complete. However, both these designs show important differences from the finished oil in the figures on either side. The drawings show on the left a beggar in check trousers and top hat holding a poodle, and on the right a single meditating 'brainworker': in the finished painting these have become the strange flower seller on the left, and Carlyle and Maurice on the right. Another idea for these figures is seen in a letter

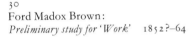

30
Ford Madox Brown:
Preliminary study for 'Work' 1852?–64

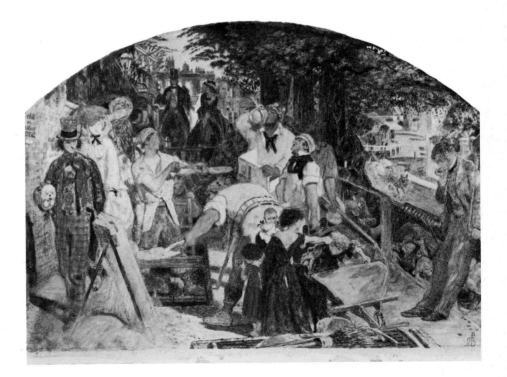

Ford Madox Brown:
*Study of the Rev. E. D. Maurice and Thomas
Carlyle for 'Work'* 1858

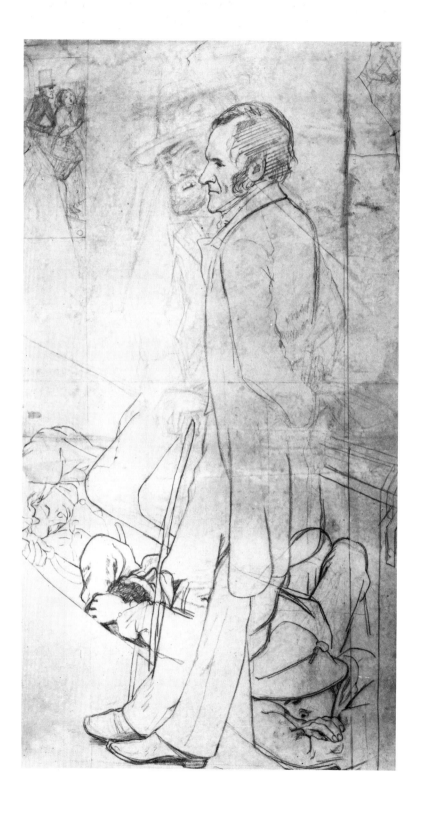

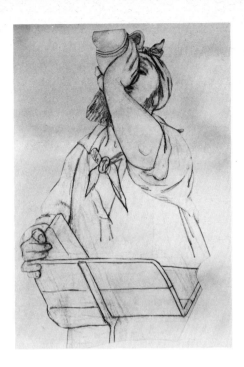

written by Thomas Plint, a Leeds merchant who, on the basis of early sketches, commissioned the painting in 1856, though he died before its completion. He wrote to Brown, 'Could you introduce both Carlyle and Kingsley, and change one of the four fashionable young ladies into a quiet, earnest, holy-looking one, with a book or two and tracts? I want this put in, for I am much interested in this work myself, and know those who are' In the final picture the lady is handing out a tract entitled 'The Hodman's Haven, or drink for thirsty souls'. The model for the lady with the parasol was Brown's second wife; that for the man on horseback was the painter R. B. Martineau. Both Maurice and Carlyle sat for their portraits, but a photograph of Carlyle was also made to help Brown, who insisted on showing him with his mouth open, as if speaking.

The *Study of Carlyle and Maurice* (31) shows the figures the same size as the finished picture, and so does the cut-out *Study of the beer-drinking navvy* (32). These were probably both drawn in connection with a full-size cartoon, from which the entire composition was transferred to the canvas. On the drawing of Carlyle and Maurice is a small sketch of the incident in the right background, showing a policeman moving along an orange-seller.

Despite its too dazzling accumulation of minute detail in sharp focus, which has to be read close to the surface, *Work* is a stunning picture, an epic of mid-Victorian life. It is Brown's masterpiece.

But such masterpieces were not financially rewarding in relation to the time spent making them, and at the same time Brown had to paint smaller pictures in

the hope of making sales. An enchanting example is *Out of town* (33), a picture of a mother and baby visiting a farm, with a child trying to stop a turkey from pecking at a bunch of grapes. This unpretentious little subject has an interesting history, as it was sketched in Paris in 1843, at a time when Brown was painting grandiose historical pictures. It shows Brown's first wife and their daughter Lucy (later Mrs William Michael Rossetti). The child with the grapes was one from the neighbourhood. Brown took the picture up again in 1858, and he sold it the same year.

Also dating from this period is *Stages of cruelty* (34), a moral subject showing a lovesick man pleading with a young woman. Her heartless treatment of him is echoed in the girl's behaviour to her dog, which she is beating with a spray of love-lies-a-bleeding. The picture is spoiled by the grimacing faces, though the painstaking treatment of the lilac leaves and brick wall (in the artist's garden) is a Pre-Raphaelite *tour de force*. This picture was begun in 1856 and was in hand in 1860, but failed to find a buyer, perhaps because of its didactic subject matter. It was painted in direct emulation of Hogarth's prints of the same title, on the theme of cruelty to animals. Much later it was re-commissioned and was finished in 1890, three years before Brown's death.

Finally, a family portrait, pure and simple, without moral overtones, *The English boy* (35). The artist's son Oliver was five when he had his portrait painted holding a whip and top, and wearing a smock and straw hat. In an age of sentimental child portraits, this rosy-cheeked boy, staring dead-pan out of the canvas, is a tribute to Brown's penetrating and truthful eye. Oliver was a precocious child who loved writing and painting; his own pictures will be discussed later (see page 120).

33
Ford Madox Brown:
Out of town 1843–58

34
Ford Madox Brown:
Stages of cruelty 1856–90

35
Ford Madox Brown:
The English boy (Oliver Madox Brown) 1860

William Holman Hunt:
The lantern maker's courtship c. 1854–60

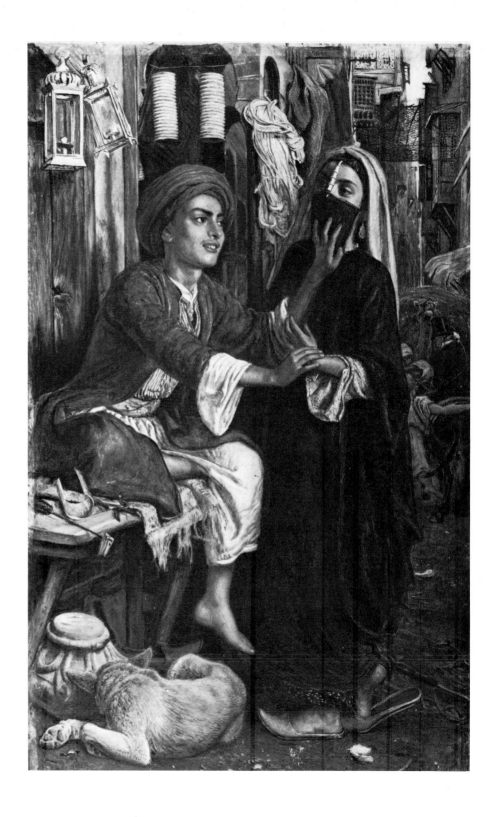

Holman Hunt in the Holy Land

In 1854, Hunt left England for Palestine in search of authentic settings for biblical paintings. He travelled in Egypt, and, stopping in Cairo, he began not a religious picture, but a genre subject, based on an incident seen in the bazaar. In *The lantern maker's courtship* (36) the girl's veil must not be lifted for religious reasons, so her smiling suitor presses the veil against her face to discover the outline of her features. In the background, beneath a jumble of screens and balconies, is a narrow alley bustling with natives rushing about, a heavily laden camel, and a top-hatted Englishman, for which Millais posed back in London, where Hunt finished the picture. The Manchester painting is a small version of one at Birmingham, and is probably by Hunt himself, despite his own denial, made in 1906 when he visited the Gallery to see a large exhibition of his work. The colours are very bright, particularly the lantern maker's green turban and red coat, and the girl's blue robe shot with green.

If the colours of *The lantern maker* are bright, those of *The Scapegoat* (37 + colour plate v) are lurid: the dark brown goat, its eyes upturned, its tongue hanging out, stares half balefully, half pathetically from in front of a strident rainbow and a yellow sunset which colours the arid hills hot purple and pink. The significance of the goat causes viewers some puzzlement, but the image alone has great power, as the perceptive Madox Brown observed: 'Hunt's *Scapegoat* requires to be seen to be believed in. Only then can it be understood how, by the might of genius, out of an old goat, and some saline incrustations, can be made one of the most tragic and impressive works in the annals of art.'

The scapegoat of the Old Testament and the Talmud was the unfortunate beast which, on the Jewish Day of Atonement, was cast out into the wilderness, bearing the sins of the people, as a symbolic act of expurgation. A fillet of scarlet thread was wound about its horns in accordance with Isiah's promise of forgiveness: 'Though your sins be as scarlet, they shall be as white as snow: though they be red like crimson, they shall be as wool.' Like Christ, the goat died for the sins of the world.

Hunt began the large version (in the Lady Lever Art Gallery, Port Sunlight) in 1854 at Oosdoom, on the edge of the Dead Sea. He painted much of the landscape out of doors, drawing and modelling by day and correcting the colours at each sunset. Four goats were used: the first was taken to the Dead Sea, but died on the

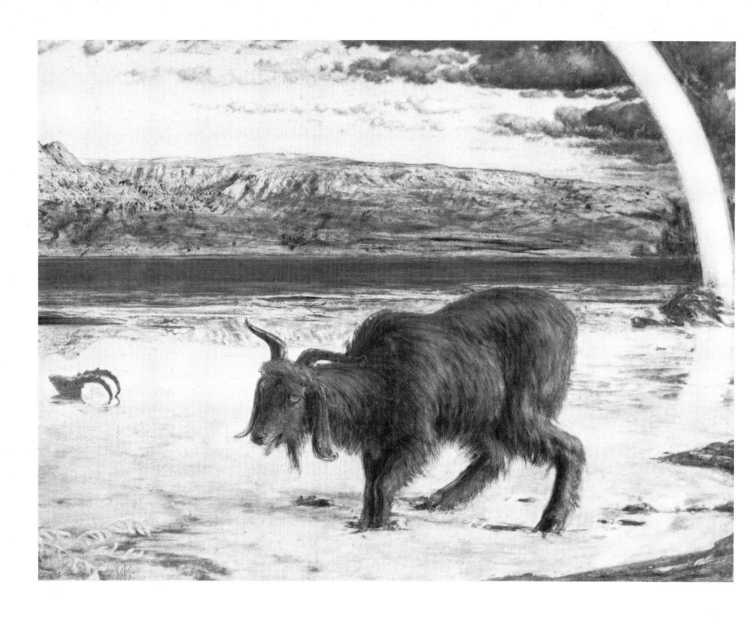

37
William Holman Hunt:
The Scapegoat 1854–5

return journey, and the last, obtained in Jerusalem, was set in a tray containing samples of mud and salt brought back from Oosdoom; such was Hunt's dependence on literal observation, he seemed at times incapable of imagining anything.

The Manchester panel, with a dark goat and a rainbow, was begun as an experiment on Hunt's first visit to the Dead Sea, when he was impressed by a large rainbow. In the large version the goat is white, the details of the incrustations are sharper, there are more bones and the rainbow has been omitted. But the presence of the rainbow in the Manchester panel recalls God's covenant with Noah, providing a note of hope in an otherwise desolate scene.

38
William Holman Hunt:
The Shadow of Death 1870–3

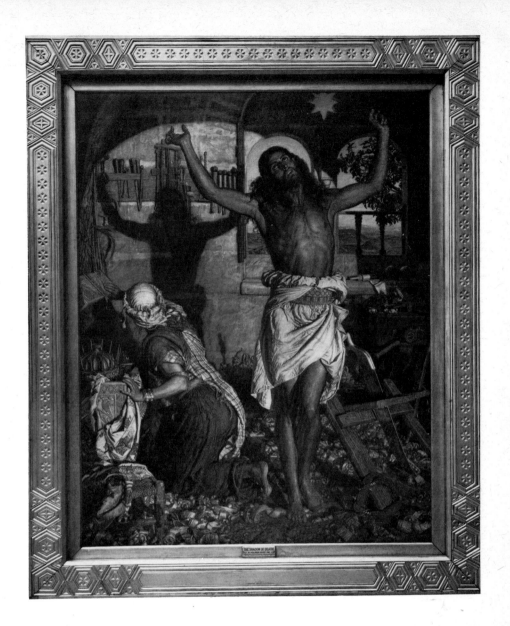

The Shadow of Death (38 + colour plate VI) was painted on Hunt's second visit to
Jerusalem, and, with all the preparatory work, studies and versions, occupied him
from 1869 to 1873. As in *The Light of the World* and *The Scapegoat*, Hunt was
seeking for a new religious image, not following traditional ways of showing
Biblical events. He wished to show Christ in full manhood, not as a child (as in
Millais' *Christ in the Carpenter's Shop*), nor as a priest performing spiritual acts, but
as a humble workman, 'while still gaining His bread by the sweat of His face'. This
was in keeping with modern preoccupations. Hunt wrote, 'One of the problems of

our age concerns the duty of the workman; His Life, as now examined, furnishes an example of the 'dignity of labour.' So Christ is shown life-size, semi-nude, an image of beauty, but one not inconsistent with the tools and woodshavings of the workshop. And the Virgin is shown with her face concealed, perhaps to show the painter's attitude to the excessive veneration of Mary.

The incident Hunt devised was a naturalistic one, but one which gave him the opportunity to create an image with spiritual meaning. Christ is shown at the end of the day's work, stretching his body and throwing up his arms to relax from the labour of sawing: his pose is akin to the Oriental attitude of ecstatic adoration. The room is filled with the light of the evening sun, which casts the shadow of his body on the tool rack on the wall, a kind of prophecy of the crucifixion. This suggestion is amplified by other details: the shadow of the saw hints at the lance, used to torment Christ on the cross, and the tools are like the nails and other instruments of the passion. The arched window behind his head is like a halo, but can be read entirely naturalistically. (A small preparatory version has square windows.) The Virgin, startled by the shadow, kneels in front of an ivory casket, containing the gifts of the wise men, recalling Christ's nativity. Thus birth, life and death are all naturally contained in the one painting.

Hunt, as usual, took great pains over every detail. His attitude to the act of painting seems itself religious, a kind of spiritual and moral struggle, a conviction that an artist too must earn his bread by the sweat of his brow. So he struggled with every detail and recorded his anguished progress in his diary, his difficulties with models, with drawing and colour, with working out of doors in different weathers, with working on such a large scale.

Many of the problems were perhaps of his own making, but again it was a religious imperative with Hunt to paint authentic detail in the authentic light

39
William Holman Hunt:
Study of a head (Edith Holman Hunt) 1884

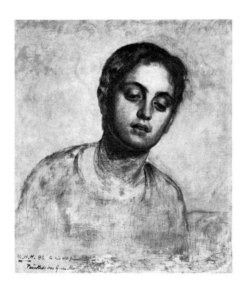

40
William Holman Hunt:
Study: sunset

conditions of the actual places where the sacred events had happened. Thus he began work (on a small canvas) at Bethlehem, where he painted in a carpenter's shop, and on the roof of a house 'where the horizontal sunlight shone uninterruptedly'. He visited Nazareth to get the view through the window, showing the hills of Galilee, the plain of Jezreel and the mountains of Gilboa beyond. The large canvas was painted in Jerusalem, on the roof of his house, and two moveable booths were constructed, one shaded for the artist to paint in, and another to shelter the model, and wheeled into place every afternoon to catch the horizontal beams of the setting sun. The tools on the rack were from a collection of ancient implements purchased at Bethlehem, and the textiles, the casket and its treasures were all taken from Oriental sources. The Christ was idealised from a variety of models, but based on natives of the Holy Land, departing from the usual dark-haired image of Christ. Thus Hunt's picture was imbued with a new truth, both spiritual, in its selection of incident and location, and scientific in its use of modern knowledge of costume and detail: a truth which Hunt felt was lacking from many traditional religious pictures.

It was shown on its own in London in 1873 and on the whole was greeted with success. Individualist though he was, Hunt was now a respected and famous artist, and in any case the painting was less obscure in idea, and less offensive in colour than some of his earlier works. Hunt also took the precaution of issuing an explanatory booklet for the exhibition. The painting was shown at Oxford, where he noted that its portrayal of Christ as a workman was felt to be blasphemous by the extreme High Church party, but when shown in the North of England, it was successful amongst the artisans and working men. It subsequently achieved a wide popularity through the engraved version.

Hunt's later work is represented in the collection by *The Lady of Shalott* (52) and by two minor studies. The unfinished *Study of a head* (39), dated 1884, shows Hunt's second wife Edith, and is possibly a study for the Virgin in *The Triumph of the Innocents* (Walker Art Gallery, Liverpool). The watercolour *Study: sunset* (40) is undated, but is an example of Hunt's interest in odd light effects, seen for example in *The Afterglow in Egypt* (Southampton Art Gallery) or *London Bridge on the night of the Royal Wedding* (Ashmolean Museum, Oxford). The Gallery also has the artist's palette, brushes, palette knife, pen, spectacles, and his Royal Academy student's card, signed by George Jones, the Keeper. The palette is inscribed, 'Painting is the Grandchild of Nature and the Kinswoman of God'.

41
Frederick Smallfield:
Early lovers 1858

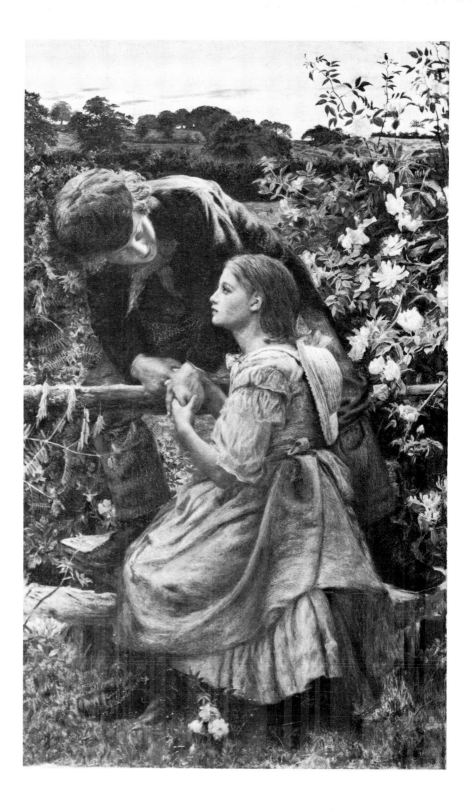

Pre-Raphaelite influence

By the late 1850s Pre-Raphaelitism had become acceptable, and many artists not associated with the original Brotherhood adopted the brightly coloured, sharply detailed naturalistic manner.

Early lovers (41) by Frederick Smallfield was inspired by a ballad by Thomas Hood.

'It was not in the Winter
Our loving lot was cast;
It was the Time of Roses,
We pluck'd them as we pass'd!

That churlish season never frown'd
On early lovers yet:
Oh, no – the world was newly crown'd
With flowers when first we met!'

The lovers are set amidst a tangled screen of ferns, leaves and roses, an effect beloved of the Pre-Raphaelites. The sense of poetry and the treatment of the distant skyline recall Millais, whom Smallfield knew. Both were members of the Junior Etching Club which in 1858 produced a series of illustrations to Hood's poems, etched by the different members. Smallfield's oil has the same composition as his etching. His later work is not particularly Pre-Raphaelite in character.

This is also true of the later work of James Archer, who painted *La Mort d' Arthur* (42) in 1860. This was one of a number of Arthurian scenes he produced about this time, reflecting the fashion in Pre-Raphaelite circles for scenes from the *Mort d' Arthur* and for medieval romance in general. Archer's pictures of this type employ jewel-like colours and sharp detail but rather conventional compositions, rejecting Pre-Raphaelite flatness and angularity. Three queens and the Lady of the Lake attend Arthur at his death, as described in Malory's epic, and Arthur gazes at a vision of the Holy Grail. Archer's later work consists of sentimental costume pictures, academically treated, and portraits, including many of children in fancy-dress. In 1903, towards the end of his life, he painted the unremarkable portrait of the Lakeland writer *Thomas de Quincey* (43) who died in 1859. De Quincey was originally a Manchester man, hence the commission to paint a posthumous portrait, done by Archer from sketches made of the poet about fifty years previously.

42
James Archer:
La Mort d' Arthur 1860

43
James Archer:
Thomas de Quincey 1903

The outlaw (44) by William Windus is an unusual and original composition, using the favourite Pre-Raphaelite devices of a flat screen of foliage and a high horizon line, but tilting it and dropping the figures until they are almost slipping out of the picture. It is only just apparent that an arrow is being plucked from the body of the outlaw, whose head the woman is embracing. Even less apparent is the tiny animal leaping through the undergrowth at the back. The effect is disturbing and mysterious. Windus was a Liverpool follower of the Pre-Raphaelites, who almost gave up painting after Ruskin criticised one of his major works. His later work is not as original, judging from the portrait of *Samuel Teed* (45), a relation of the artist's son-in-law.

W. J. Webb painted a number of works in a microscopic Pre-Raphaelite style, akin to that of Holman Hunt, in the 1850s. In 1862 he visited the Holy Land; the barren landscape, lurid lighting and biblical subject-matter of *The lost sheep* (46) owe an obvious debt to Hunt.

44
William Lindsay Windus:
The outlaw 1861

45
William Lindsay Windus:
Samuel Teed

R. B. Martineau was, unlike Webb, a formal pupil of Hunt in the 1850s, and he intermittently shared Hunt's studio until 1865. His most famous picture, *The last day in the old home* (Tate Gallery) is highly finished and crammed with anecdotal detail, but he was a slow worker, and as he died at the age of 43 he left few completed works. The study for *A woman of San Germano* (47) is for a painting of an Italian peasant woman seated beneath a pergola of vines (fig. vii). Manchester also has several of his pencil drawings (48 a–c) and an attractive portrait of the artist's wife, wearing a red cape (49).

John Brett was a Pre-Raphaelite follower whose landscapes of the late 1850s attracted the attention of Ruskin, who admired Brett's depiction of geology and his delicate precision. In Brett's late work, of which two examples are at Manchester, there is more precision than delicacy. The small *Seascape* (50) of 1881 is a free-handled sketch; in contrast the large *Norman Archipelago* (51) is a highly finished work, shown at the Royal Academy of 1885. The large scale makes its accuracy seem dry and mechanical, though it is nevertheless impressive. As Ruskin remarked of another of Brett's works, 'it seems to me wholly emotionless . . . I never saw the mirror so held up to nature, but it is Mirror's work, not Man's.'

Pre-Raphaelite influence was also spread by illustrations in books and magazines: the 1860s were a golden age for illustration, and the Pre-Raphaelites

46
William J. Webb:
The lost sheep 1864

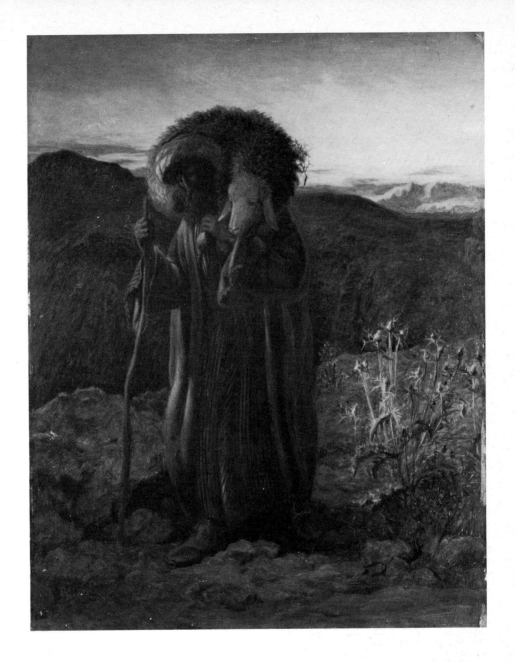

made a major contribution. The stylisation and economy required by the restriction to black and white in a small format led to some striking and inventive designs. In the printed illustrations, the artist's original conception was seen through the intervention of another craftsman, for the printing technique was by wood-block, and the artist's drawing, often made directly onto the wood, was cut out by skilled wood-engravers, like the Dalzeil brothers. Some of the freedom

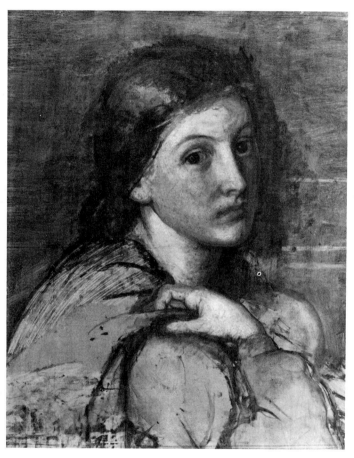

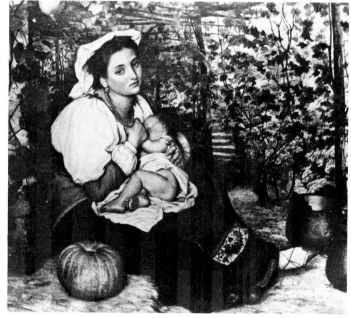

47
R.B.Martineau:
Study for 'A woman of San Germano' c. 1864

Fig. vii
R.B.Martineau:
A woman of San Germano, oil on canvas

48
R.B.Martineau:
a. *Study of a woman's head*
b. *Study of a man's head*
c. *Study of a woman's head, looking down*

49
R.B.Martineau:
The artist's wife in a red cape

50
John Brett:
Seascape 1881

51
John Brett:
The Norman Archipelago 1885

given by pen and ink was of necessity lost, though the engravings were surprisingly faithful and the artists adopted an economical, concentrated style to suit the medium.

Often the drawings and engravings were re-used for finished oil paintings. This is the case with Hunt's *Lady of Shalott* (52) which began as a drawing of 1850 (National Gallery of Victoria, Melbourne, fig. viii). Later Hunt adapted the image for the most famous book to be illustrated by the Pre-Raphaelites, the edition of Tennyson's poems published by Moxon in 1857. For this Hunt provided several illustrations including one for the Lady of Shalott, illustrating the dramatic moment when her mirror cracked (fig. ix).

'She left the web, she left the loom,
She made three paces thro' the room,
She saw the water-lily bloom,
She saw the helmet and the plume,
 She look'd down to Camelot.
Out flew the web and floated wide;
The mirror cracked from side to side;
"The curse is come upon me," cried
 The Lady of Shalott.'

Tennyson criticised Hunt for showing the hair wildly tossed about as if by a tornado, and for having the web wound round her like the threads of a cocoon: 'An illustrator ought never to add anything to what he finds in the text,' he maintained, despite Hunt's plea that he only had half a page to make an impression, where the poet had fifteen.

Years later, in 1886–7, Hunt returned to the design and painted two versions in oil, a large one now at the Wadsworth Athenaeum, Hartford, Connecticut, and the small one at Manchester. Both reflect the more decorative approach of Rossetti's later work. The two versions, which differ slightly from each other, have more elaborate details than the print, such as the seven-branched candlestick, the doves, and a relief of cherubs above. Hunt planned the details with typical thoroughness: he drew a design for the tapestry on the loom, though it is not known if this was ever woven. He also modelled a plaster relief of *Hercules in the Garden of the Hesperides* (53) for the oval sculpture on the right in the Hartford painting: in the Manchester version he substituted for it *Christ in Majesty*. For the mirror, he studied fractured glass, and over a period of three years a model sat for the hair, which was draped over an easel. The painting is dramatic and mysterious, but curiously complex with the strange circular form of the loom and the spatially confusing reflection in the mirror, showing Sir Lancelot seen through a traceried window, a sunlit vision of nature in a rich and dark room of art. Hunt later put a moral interpretation on Tennyson's tale of love, for he felt that the Lady, distracted by outside reality, was neglecting her proper spiritual duty.

Another painting based on an earlier illustration is *The traveller* (54) by Ford Madox Brown, to a poem of Victor Hugo. The illustration was published in *Once*

Fig. viii
William Holman Hunt:
The Lady of Shalott, pen, ink and black chalk

Fig. ix
William Holman Hunt:
The Lady of Shalott, wood engraving

William Holman Hunt:
The lady of Shalott
c. 1886–1905

54
Ford Madox Brown:
The traveller 1868–84

55
Ford Madox Brown:
The Corsair's return 1860

a Week in 1859: the oil replica was done in 1884, and is a charming rendering of night outside an inn, the traveller urging his horse round the corner where a wayside shrine and a lamp at a *château* gate can be seen. Outside the inn, a family group watches, as guests eat and drink within.

Brown also illustrated an edition of Byron, published in 1869, and one of his drawings shows *The Corsair's return* (55). Conrad, the pirate captain, returns from battle to find his betrothed Medora dead. The stooping, powerful figure of Conrad contrasts with pale Medora laid out on her death bed.

57
Arthur Hughes:
The youngest child's death 1866

Another poignant death-bed scene was among the illustrations by Arthur Hughes for an edition of Tennyson's *Enoch Arden*, published in 1866. The hero of the poem was forced to seek his fortune at sea, leaving his poor wife and children behind (*Enoch's farewell*, 56). Soon after his departure one of his children died (*The mother's vigil*, 57). Marooned for many years after a shipwreck (*The shipwreck island*, 58), Enoch returned, only to learn that his wife, assuming he was dead, had married his best friend and become prosperous and happy: not wishing to destroy this happiness, Enoch did not disclose his identity and took his secret to the grave.

58
Arthur Hughes:
The shipwreck island 1866

Rossetti and the second phase of Pre-Raphaelitism

The naturalistic vein of the movement attracted many followers, but others were highly influenced by the more imaginative and decorative work of Rossetti, about whom gathered a group of younger artists drawn by his bohemian personality, as well as by his visionary style.

Rossetti went to Oxford in 1857 to decorate the Debating Hall (now the Library) of the Oxford Union, with a series of murals to Malory's *Mort d'Arthur*. There he was joined by six other artists, some old friends like Arthur Hughes, others, like Edward Burne-Jones and William Morris, young disciples of Rossetti who had given up their studies at Oxford for art. This band of enthusiasts set to work merrily and completed their work to the accompaniment of practical jokes and laughter. The murals faded almost as soon as they were painted: none of the artists had the slightest idea of the proper technique for frescoes, and they had painted directly onto whitewashed brick walls.

The designs are known from drawings, and Rossetti's *Study of Guinevere* (59) is related to a highly finished drawing of *Sir Lancelot in the Queen's Chamber* (Birmingham City Museum and Art Gallery, fig. x). The study is inscribed 'fainting study', and shows the Queen clasping her hands to her throat, about to swoon, whilst Lancelot, caught in her chamber by his enemies, Sir Agravaine and Sir Mordred, prepares to fight them off.

Guinevere's features are not those of Lizzie Siddal: this is one of Rossetti's earliest drawings of Jane Burden, later Jane Morris, whose distinctive face was to dominate Rossetti's later work. She was at this time seventeen, the daughter of a groom, and had been spotted by the group one night at an Oxford theatre.

V.C. Prinsep, painter of the charmingly medieval *The queen was in the parlour, Eating bread and honey* of 1859 (60), was one of the young men who helped Rossetti at the Oxford Union. The queen, clad in glowing purple, is fetchingly tasting a sandwich. She is like one of Rossetti's brightly coloured and stylized Arthurian heroines, but the treatment is less expressive and more meticulous: a pretty fairy-tale rather than an intense love poem. The little picture on the wall could almost be a Rossetti; the tiny bells below the eccentric medieval detail of the metal hinges, and the decorated pot recall the medieval furniture of the architect-designer William Burges. Manchester possesses an extraordinary writing cabinet made by Burges's associate, Gualbert Saunders, in 1865 (61 + in colour on back cover). In

59
Dante Gabriel Rossetti:
Study of Guinevere for 'Sir Lancelot in the Queen's Chamber' 1857

Fig. x
Dante Gabriel Rossetti:
Sir Lancelot in the Queen's Chamber, pen and ink

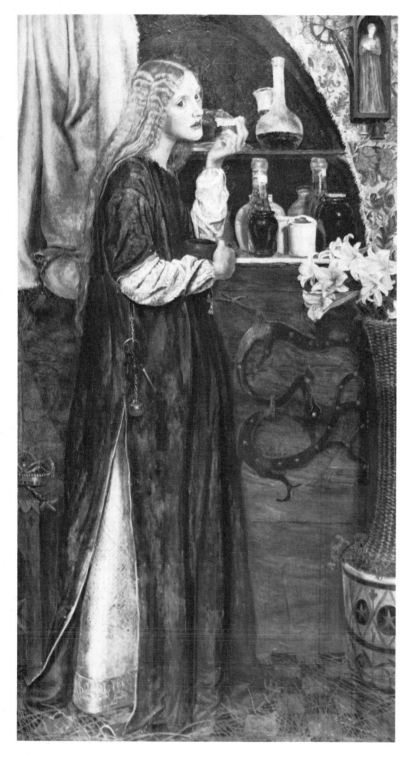

60
V.C. Prinsep:
The queen was in the parlour, Eating bread and honey
Exh. 1860

61
William Burges and Gualbert Saunders:
Escritoire 1865–7

62
V.C. Prinsep:
Cinderella Exh. 1899

63
V. C. Prinsep:
At the Golden Gate Exh. 1882

Burges's work the medieval dream world of the Pre-Raphaelites takes solid form. Absolutely non-functional, the cabinet is a fantasy piece, painted all over and incorporating tiles, bells, a clock, a calendar, shutters and doors which go up and down, and a pitched roof painted with fish-scale tiles. The decoration includes butterflies, caterpillars, birds, and figures in medieval dress representing the ages of man, the arts, and the estates of society. Also present are the butcher, the baker and the candlestick-maker, nursery rhyme figures like the queen in the parlour herself.

Prinsep eventually became a Royal Academician, and his latter work is much less exciting: despite its fairy-tale subject, *Cinderella* (62) has none of the delight of *The queen was in the parlour*. *At the Golden Gate* (63) dates from after his visit to India in 1876–7. He went there to paint for Queen Victoria a large group portrait of the Imperial Durbar at Delhi: but the woman at the Golden Gate is a Western beauty, despite her Eastern setting, and recalls the statuesque classical figures of Lord Leighton. The subject comes from the parable of the wise and foolish virgins, and shows one of the foolish virgins locked out because she has not trimmed her lamp.

A direct reflection of the Oxford Union murals is the decorative scheme of Penkill Castle, Ayrshire, painted by William Bell Scott, a friend of Rossetti who was head of the Newcastle School of Art. A Scottish baronial castle, dating from the fifteenth century, Penkill was given Victorian improvements, including a castellated round tower containing a spiral staircase. Scott's mistress Alice Boyd, the owner of the castle, commissioned him to decorate the stair, and he chose for his subject *The King's Quair*, the courtly love poem written by James I of Scotland whilst a prisoner at Windsor in 1450, to celebrate his love for Jane, daughter of John of Gaunt. Christina Rossetti was the model for Lady Jane. The murals were painted between 1865 and 68, using a medium of wax and turpentine. At Manchester there are four drawings for an early stage in the design: in the final version the seven scenes are more spread out, as the panels are wider.

James reading Boethius (64) illustrates the first Canto: it is early morning, the night watch is going home and the young King, seen through a window, top right, consoles himself for his imprisonment by reading Boethius, author of *De Consolatione Philosophiae*, which he also wrote whilst in prison: a statue of Boethius reading is at the right. *Lady Jane in the garden* (65) illustrates Canto 2. Out of the window, James sees Lady Jane walking in the garden with her two maids and her pet dog. Cupid fires his arrows at the prince. The Three Fates above were painted over a window on the stair. *The Court of Love* (66) illustrates the fourth Canto. In Canto 3, James is taken by Cupid to the Court of Love. Here, in Canto 4, is a fountain surrounded by all the lovers recorded in history. Behind, James kneels before Queen Venus who reclines on a couch. She sends him to the Court of Wisdom to seek Dame Minerva's advice. Cupid, above, was painted over a window on the stair. *James receiving Jane's carrier pigeon* (67) shows the final Canto: the King in his tower room receives a pigeon as a token of love sent by Jane.

64
William Bell Scott:
James reading Boethius
1865/8

65
William Bell Scott:
Lady Jane in the garden
1865/8

66
William Bell Scott:
The Court of Love
1865/8

67
William Bell Scott:
*James receiving Jane's carrier
pigeon* 1865/8

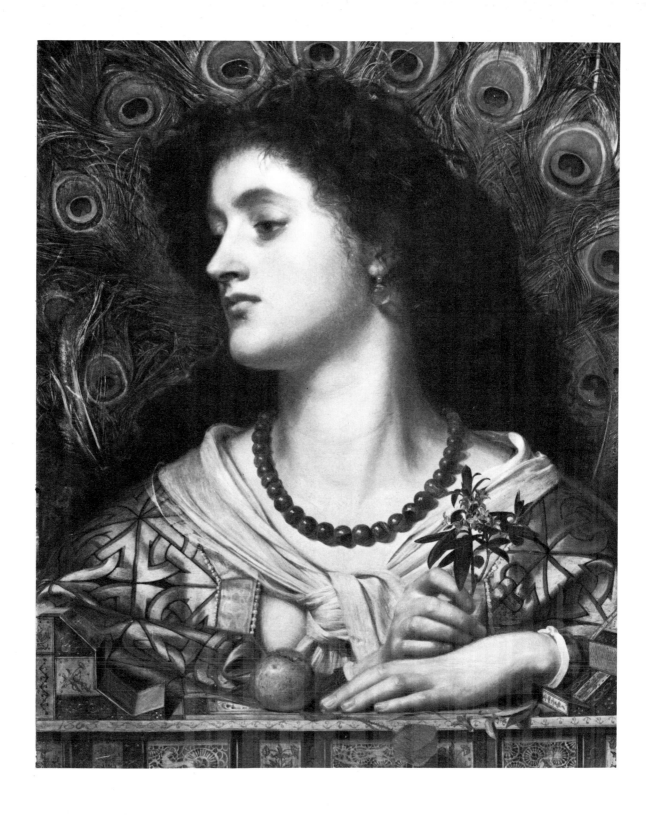

Another associate of Rossetti, Frederick Sandys, painted *Vivien* (68) in 1863. This fanciful portrait of a luxuriously attired female conveys a heady atmosphere of sensuality and mystery, with none of the directness of the early Pre-Raphaelite vision. This type of half-length female portrait, cut by a parapet, is based on Venetian models, but was adopted by Rossetti in the late 1850s and 60s, and taken up by his followers. *Joli cœur* (69) of 1867 is a typical example of Rossetti's own work in this vein.

Both figures have the air of a *femme fatale*, with the full lips, broad neck and flowing hair admired by Rossetti. *Vivien*, painted in the bright and sharp style of early Pre-Raphaelitism, shows the enchantress of Arthurian legend. The apple and rose refer to her role as temptress, and she holds a sprig of daphne, a plant both beautiful and poisonous. *Joli cœur* is painted more broadly, like all Rossetti's later work, and has less of a literary pretext. The title comes from the heart-shaped pendant so suggestively held out by the model. She appears to be undressing, unbuttoning her fur-trimmed dress of Chinese silk to reveal her underwear.

Rossetti at this time painted several large canvasses of sensual and alluring ladies, and indeed *Joli cœur* is a version of one of the figures in *The Beloved* (Tate Gallery, fig. xi) which shows the bride and her handmaidens from *The Song of Solomon*. One of the maidens wears the same jewelled spiral hairclip seen in *Joli cœur*: Rossetti was interested in jewellery and designed some pieces himself.

Whilst Rossetti's early work was inventive, private, modest in scale, and intense, these erotic pictures are more obvious, often larger, and sometimes rather vulgar: the literary pretext is loose, and there is an excessive reliance on worldly female beauty and sumptuous accessories. This was partly due to a decline in Rossetti's powers as a painter and partly a response to the demands of a new opulent type of collector; but it was also a new interest in decorative effect for its own sake. This is characteristic of the Pre-Raphaelite movement from the 1860s and 1870s onwards: the hard, bright and factual style of the early years, the poetic intensity, the interest in modern subjects, the minute detail, all were left behind for a new style totally opposed to the original aims of the movement. This second phase of Pre-Raphaelitism was a style of soft colours, and lack of definition, of imaginary visions and mysteries, of decorative outlines and patterns. This kind of Pre-Raphaelite painting was not a representation of a realistic scene, but an imagined idea, presented as a beautiful artefact.

Here, Pre-Raphaelitism shades into the aesthetic movement of the 1870s and 80s, in which effects of form and colour were pursued at the expense of subject matter. Whistler, the apostle of art for art's sake, entitled his portraits 'arrangements' of form and colour: the sitters' names were subsidiary. Rossetti did not go to such extremes, but knew Whistler and was a near neighbour of his. For a time Sandys and the poet Swinburne shared Rossetti's house. They were all interested in Japanese art, with its bold, flat stylisation, and were also familiar with the ideas of French aestheticism, of art as independent of morality, and beauty as present in evil as well as good. This accounts for the fascination with the *femme*

69
Dante Gabriel Rossetti:
Joli cœur 1867

Fig. xi
Dante Gabriel Rossetti:
The Beloved (or *The Bride*)

Fig. xii
Detail of frame of Rossetti, *Astarte Syriaca*

fatale, as well as for the broadening of style, the flat claustrophobic space and the interest in decorative effects provided by flowers, jewellery, and patterned fabrics. Rossetti and his circle also experimented with novel frame designs. They complemented the flat, decorative qualities of their pictures by flat gilt surrounds, often restricting the ornamentation to medallions of Oriental design (fig. xii). The Pre-Raphaelites had always been very concerned about the way their pictures were framed, and Manchester has many examples of frames specially designed or chosen by the artists to complement their pictures thematically as well as visually (front cover, 17, 38).

Rossetti's interest in curvilinear motifs, seen in swirling draperies, hair, and mannered hand positions, as well as in patterned objects and frames, is a foreshadowing of the later Art Nouveau style.

There is also a foreshadowing of the Symbolist movement, for Rossetti's interest in art for art's sake was never complete. Though decoratively treated, his paintings arose out of his personal life and his poetry, and always had some meaning, however vague and introspective. In this sense he was true to a part of his Pre-Raphaelite beginnings, for his art never divorced itself entirely from ideas or literature.

Rossetti's late paintings

During the later 1860s and 1870s, Rossetti continued to paint decorative and imaginary subjects using a broadly painted style, but his interests changed. The appeal of pagan and fleshly beauty faded, and his women became more other-worldly, melancholy and poetic. This is seen, for instance, in *The bower meadow* of 1872 (70 + colour plate VIII), where two women play musical instruments, and two dance together in dreamlike rhythm, each pair composed in opposing, lazy curves. The green landscape background was done in the 1850s as we have seen: in 1872 Rossetti returned to his unfinished canvas (intended for *Dante and Beatrice in Paradise*), put in the figures and gave it a fanciful title. He also re-used the jewelled hair-clip of *Joli cœur*.

Rossetti's depictions of melancholy female beauty coincided with his growing love for Jane Morris, wife of his friend William Morris. Her features came to dominate his work, and even when other models were used, as in the case of *The bower meadow*, they were of the same type.

Jane Morris is seen in a number of roles in a series of drawings of 1869–70. *Pandora* (71), a mistily soft pastel drawing is a study for a full-length oil of the unhappy goddess who unwittingly admitted evil into the world by looking inside the casket she was forbidden to open. *Silence* (72), in pencil, shows her seated, bending her head forwards and drawing a curtain round her. Her lips are sealed but her large eyes gaze out as if she has some terrible secret she cannot tell. The larger and more finished pastel *La donna della fiamma* (73) in delicate shades of brown, shows her holding a mysterious flaming figure. In all three, Mrs Morris's striking features, her dark eyes, full lips, prominent chin, long neck and flowing hair, are softened and idealised into a face of strong presence, but with a dream-like, withdrawn character: photographs show that the likeness was very accurate. Her face looks out from almost all Rossetti's late work, and the repetition, which some find wearisome, can only be explained by an emotional obsession, intensified by an increasing reliance on drugs. But these drawings are not simply fanciful self-indulgences: Rossetti wanted to convey a more general view of the forces of love, and, for instance, wrote that in his pictures of women the mouth represented the sensual and the eyes the spiritual. This interest in symbolism is seen at its height in two elaborate late works which present the *femme fatale* as a kind of love goddess with specific meaning. This meaning is closely related to Rossetti's poetry, and he

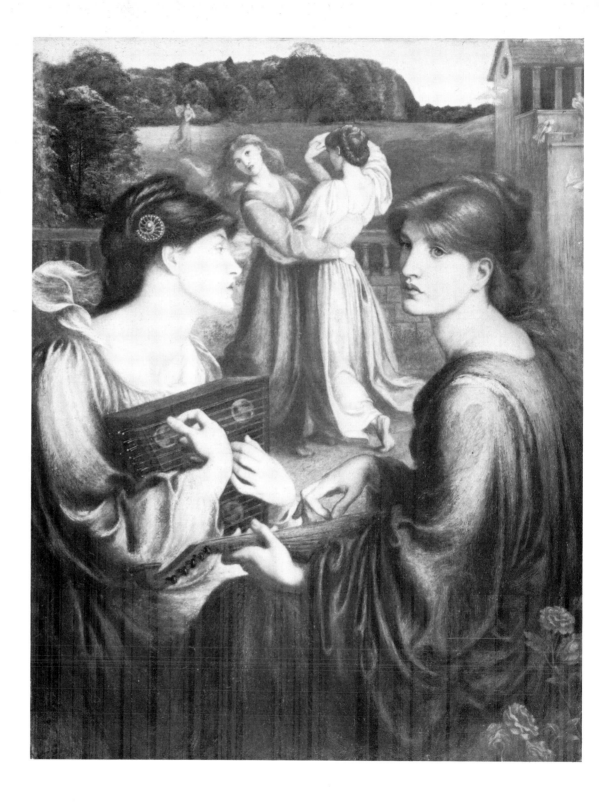

70
Dante Gabriel Rossetti:
The bower meadow 1850–72

71
Dante Gabriel Rossetti:
Study for 'Pandora'
1869

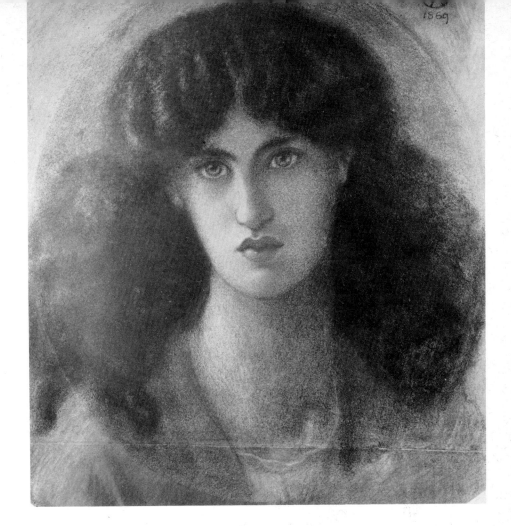

very often conceived of a poem and a picture together, inscribing verses on the
frames. The pastel study for *The Blessed Damozel* (74) shows the goddess with stars
in her hair, as in Rossetti's poem.

> 'The blessed damozel leaned out
> From the gold bar of Heaven;
> Her eyes were deeper than the depth
> Of waters stilled at even;
> She had three lilies in her hand,
> And the stars in her hair were seven.'

She is the central figure of the large oil painting, now at the Fogg Art Museum,
Harvard University, which depicts her in heaven, surrounded by re-united lovers,
and gazing down at her own love, still imprisoned on earth (fig. xiii). Even though
heavenly love is everlasting, a mood of sadness and yearning pervades the
painting.

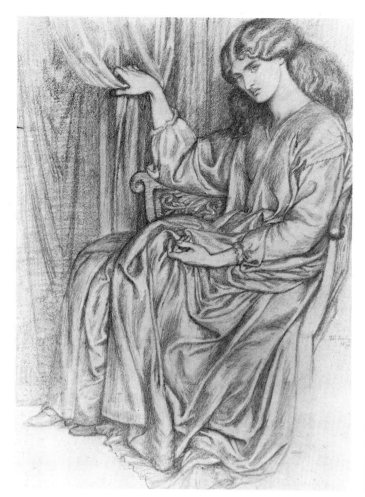

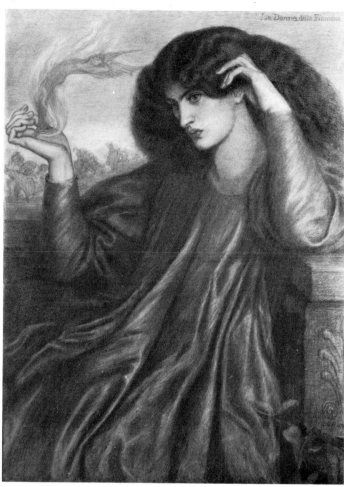

72
Dante Gabriel Rossetti:
Silence 1870

73
Dante Gabriel Rossetti:
La donna della fiamma 1870

In contrast, *Astarte Syriaca* (75) shows love as cruel and frightening, a combination of Venus, classical goddess of love, with Astarte, ancient middle-Eastern queen-goddess. Rossetti wrote a poem for the painting. Part of it is written on the frame, and the Gallery also has the complete text in the artist's handwriting.

'Mystery: lo! betwixt the sun and moon
Astarte of the Syrians: Venus Queen
Ere Aphrodite was. In silver sheen
Her twofold girdle clasps the infinite boon
Of bliss whereof the heaven and earth commune:
And from her neck's inclining flower-stem lean
Love-freighted lips and absolute eyes that wean
The pulse of hearts to the spheres' dominant tune.

Torch-bearing, her sweet ministers compel
All thrones of light beyond the sky and sea
The witnesses of Beauty's face to be:
That face, of Love's all-penetrative spell
Amulet, talisman, and oracle, –
Betwixt the sun and moon a mystery.'

Coarse in drawing and execution, lurid in colour, an overscaled and exaggerated vision of Jane Morris, the painting is nevertheless a powerfully haunting image of woman, tall, dominant, impassive and quite merciless.

The influence of Rossetti continued on a number of followers. One of these was Simeon Solomon, whose figures convey the same combination of the spiritual and the sensual seen in Rossetti: Solomon's exquisite little *Study: female figure* (76) shows a sad-eyed Venetian beauty, in richly-coloured red and blue, a careless strand of hair on her pale *décolletage*. Solomon was a homosexual, and his men are akin to Rossetti's women: the *Study: male figure* (77) is similarly mysterious, with crystal ball, starlit sky, flowing leaves, and poppies, symbols of sleep.

74
Dante Gabriel Rossetti:
Study for 'The Blessed Damozel' 1876

Fig. xiii
Dante Gabriel Rossetti:
The Blessed Damozel

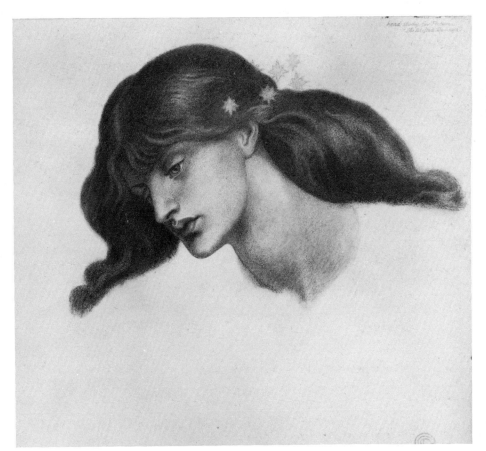

75
Dante Gabriel Rossetti:
Astarte Syriaca 1877

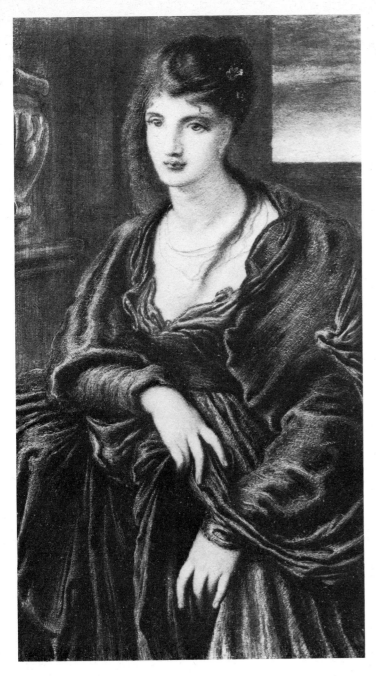

76
Simeon Solomon:
Study: female figure 1873

77
Simeon Solomon:
Study: male figure 1878

Ford Madox Brown's later work

Ford Madox Brown and Rossetti were always close friends and confidants: in the 1870s both their styles became broader and more decorative. But where Rossetti's work tended towards vapid and loose handling, Brown's was more linear and mannered. Correspondingly, where Rossetti preferred vague poetic and symbolic conceptions, Brown loved the detailed storytelling of historical and literary subjects.

A good example is *Cordelia's portion* (78), a monochrome cartoon dated 1869, made in preparation for an oil. (Versions are at the Fitzwilliam Museum, Cambridge and Southampton Art Gallery.) Much is made of the decorative play of drapery folds rippling across the surface. This rich effect is emphasised further by the intricate drawing of jewellery, patterned robes, headdresses and props, and the bustle of figures crowding round the throne. However, this is not art for art's sake, but a narrative painting showing the scene in Shakespeare's *King Lear* when the

78
Ford Madox Brown:
Cordelia's portion 1869

old king has disinherited Cordelia, and the King of France (right) takes her for his wife, with the words, 'Fairest Cordelia, thou art rich, being poor.' Brown tells the story not only by grouping, gesture and facial expression, but by details such as the map of England divided between the three sisters, with Cordelia's portion ripped; and by the way the grasping sisters Regan and Goneril and their husbands twine their fingers about the crown. It is a very original and animated treatment of a dramatic moment, full of passages of beauty and character which set it apart from the general run of history painting popular at the Academy.

A similar use of decorative outline is seen in *Byron's dream* (79). The design of the oil, dated 1876, began as a charming title-page vignette of Moxon's edition of Byron's poems, published in 1872 (fig. xiv), and formed the basis of a later watercolour version, now in the Whitworth Art Gallery, Manchester.

79
Ford Madox Brown:
Byron's dream 1874

Fig. xiv
Ford Madox Brown:
frontispiece to *Byron's Poetical Works*

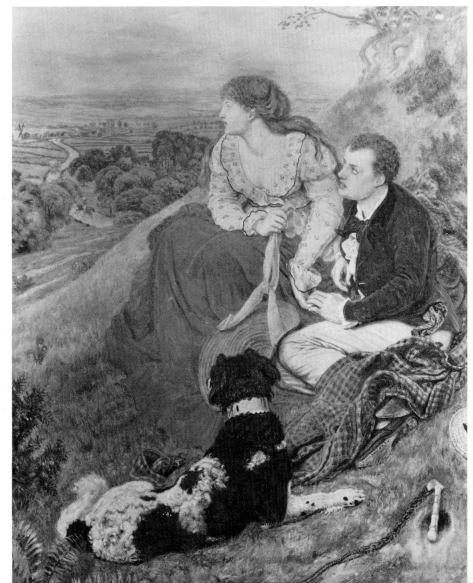

'I saw two beings in the hues of youth
Standing upon a hill, a gentle hill,
Green and of mild declivity . . .'

Taking his subject from Byron's poem, *The dream*, Brown has cleverly depicted
the poet's schoolboy passion for Mary Chaworth, whose attention is directed at
her distant lover riding towards her.

'The maid was on the eve of womanhood;
The boy had fewer summers, but his heart
Had far outgrown his years . . .
Her sighs were not for him; to her he was
Even as a brother – but no more . . .
 . . . even now she loved another
And on the summit of that hill she stood
Looking afar if yet her lover's steed
Kept pace with her expectancy, and flew.'

The landscape was done after a special journey to Newstead, Byron's home near
Annesley, where Mary Chaworth had lived.

Less decorative in conception, but still rejoicing in curved outline is *Cromwell,
Protector of the Vaudois* (80), dated 1877. Brown was a great admirer of the stern
Puritan and here shows him in his role as champion of European Protestantism,

sending the Duke of Savoy the despatch of 26th May, 1658, protesting against the cruel massacre of the Protestants.

Cromwell sits impatiently on the table, holding his notes scribbled on a scrap of paper. His Latin secretary, the blind poet Milton, composes the Protector's ideas into Latin, whilst his secretary, the poet Andrew Marvell, writes. Brown has stressed the contrast between the man of action (Cromwell is wearing armour, and is supposed to have come in from exercising his troops), and the more contemplative demeanour of the literary men, Milton spiritual, Marvell more urbane. The scene is Milton's house in Petty France (St James's Park can be glimpsed through the window), and behind the poet is his organ, which he continued to play after he became blind. The story is filled out with seventeenth-century furniture and telling props, such as the map of Savoy and the declaration of a public fast for the fate of the massacred Swiss Protestants. Here the storytelling techniques of *Work* are married to an historical subject, and to a style which is idiosyncratic, but much less startling than the Pre-Raphaelite manner.

Very similar are the magnificent series of twelve historical murals in Manchester Town Hall. They illustrate scenes from the history of Manchester and were commissioned by the City for its new Town Hall, designed in 1868 by Alfred Waterhouse and opened in 1877. The murals are the centrepiece of a decorative scheme which was to have embraced all the staterooms, though the murals in the other rooms were not carried out. But throughout all the rooms are decorative and emblematic motifs associated with Manchester: red roses for Lancashire, white strands for cotton, local armorial bearings and portrait busts of local worthies, and the whole is an opulent expression of the civic pride and commercial prosperity of Victorian Manchester. The twelve murals were originally to be shared by Brown and Frederic Shields, but in the end Brown painted all twelve. They took from 1879 to 1893, the year of the artist's death, and for part of that time Brown lived in Manchester, first at Crumpsall, then in Victoria Park. The City Art Gallery has four reduced versions of the murals, probably made as replicas to earn the artist a little extra money. (He regarded himself as underpaid by the City.) The replicas are rather coarsely executed, but nevertheless they give a good idea of the animation and inventiveness of treatment in the murals, which are best seen in the Town Hall itself, complemented by Waterhouse's rich interior setting (fig. xv).

The establishment of the Flemish weavers in Manchester, 1363 (81) is an imaginary incident, standing for the early introduction of the textile industry. Queen Phillipa of Hainault, wife of Edward III, during whose reign Flemish weavers settled in the area, is seen visiting Manchester. She is being shown samples of cloth while weavers sit at the loom on the right. The scene is bathed in gentle spring sunlight, and the Queen and her ladies bear branches of may blossom. The mural is decoratively treated, like Brown's later work, but harks back to some of the artist's earlier interests: the picturesque detail of later medieval costume, as in *Chaucer*, and the precise light conditions, contrasting direct sunlight with reflected light as in *Work*. As in all Brown's pictures, there is much humorous incidental detail: the

Fig. xv
View of the Great Hall, Manchester Town Hall, showing murals by Ford Madox Brown

81
Ford Madox Brown:
*The establishment of the Flemish weavers in
Manchester, 1363 1888*

82
Ford Madox Brown:
*The proclamation regarding weights and
measures, 1556 1889*

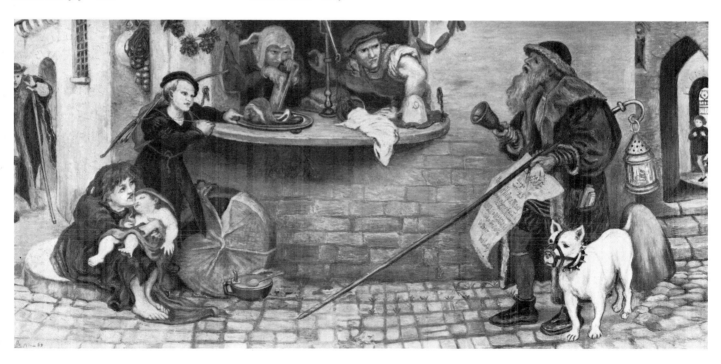

83
Ford Madox Brown:
Crabtree watching the transit of Venus, 1639
1881–8

84
Ford Madox Brown:
John Kay, inventor of the flying shuttle, 1753
(unfinished) 1888

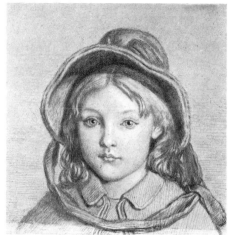

85 (left)
Ford Madox Brown:
Madeline Scott 1883

86 (above)
Ford Madox Brown:
Study for 'Madeline Scott' c. 1883

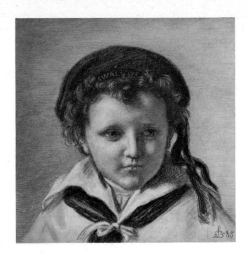

87
Ford Madox Brown:
Ford Madox Hueffer 1885

88
Ford Madox Brown:
Charles Rowley Junr. 1885

sleek court dogs sniffing at the bristling Manchester cat, and the weaver's apprentice making eyes at the lady with the kitten on the right.

The proclamation regarding weights and measures, 1556 (82) represents the supposed origin of Manchester's commercial integrity, the foundation of its Victorian trading prosperity. The crier announces the new regulations, to the dismay of the grocer, whilst his wife scrapes off butter sticking to the scales. The figures of the shopkeepers, and the delightful Cupid-like schoolboy seem to have a Mannerist source. Brown's device of putting the main composition on a shallow stage with distant views shooting back into the picture only at the sides ensures the integrity of the wall-surface. Throughout the murals Brown was at pains to emphasise the architectural nature of the scheme, by a concern for linear pattern and strongly designed compositions.

This can also be seen in *Crabtree watching the transit of Venus, 1639* (83), where the perspective space is clearly defined, yet the surface is emphasised by the ray of light and the sweeping curves of drapery. To represent Science, the mural shows the important astronomical observation of Venus passing across the sun, reflected through a telescope in a darkened room. This took place at Broughton near Manchester, and was watched by Crabtree, a draper, who had helped the learned curate Horrox in joint astronomical calculations. Crabtree is shown in an attic above his shop, and his wife and children look on whilst he himself, dropping his pipe and book, leaps up in amazement at the reflection of the planet.

The last mural replica at Manchester is an unfinished one for *John Kay, inventor of the flying shuttle, 1757* (84) being smuggled out of his house at Bury, wrapped in a wool sheet, to escape the mob of machine breakers, whose livelihoods were threatened by the new invention. The outline of the flying shuttle loom is clearly visible at the edge of the unfinished portion.

The murals were the major imaginative effort of Brown's last years, and they include such portraits of friends and family as his second wife Emma as the queen in *The Flemish weavers* and his daughter Lucy as Mrs Crabtree. At the same time he also painted a number of independent portraits, including some of Manchester sitters. The little girl riding a tricycle, painted in 1883, is *Madeline Scott* (85), daughter of C.P. Scott, editor of the *Manchester Guardian*. She kept up her journalistic connections, for she later married C.E. Montague, of the same newspaper.

The preparatory study of her (86) is one of several chalk portraits of this period: Brown's grandson *Ford Madox Hueffer* (87) in a sailor suit; and *Charles Rowley Junr.* (88), the Manchester frame-maker and educationalist, who was influential in obtaining the murals commission for Brown. Rowley started the Ancoats Brotherhood, an organisation which held lectures, exhibitions and concerts in one of the poorest quarters of the city. Amongst those whom Rowley persuaded to lecture were Brown, Walter Crane, William Morris, Bernard Shaw, G.K. Chesterton, and Canon Rawnsley, with music by Sir Charles and Lady Hallé.

Brown also took part in the great Royal Jubilee Exhibition held in 1887 in

Manchester to mark Queen Victoria's Jubilee. For the central dome of the exhibition building, which was a temporary cast-iron and glass structure in Old Trafford, Brown designed eight figures, representing *Weaving, Shipping, Spinning, Commerce, Corn, Wool, Iron* and *Coal*; each, with an accompanying angelic figure or 'spirit of energy' was painted, with the help of assistants, on to large canvasses and then set into the spandrels of the dome. *Coal* was destroyed, but the rest are in the Gallery's collection. Sadly they are in poor condition, and are too large to show, but the striking designs can be appreciated from Brown's drawings in the Whitworth Art Gallery, and an old photograph shows the originals *in situ* (fig. xvi).

Before we leave Brown, mention must be made of his dearly beloved son Oliver, who showed precocious talent as a writer and artist, but tragically died in 1874 when aged only nineteen. By this time he had published a novel, and exhibited various paintings, including *Exercise* (89) of 1870 and *An episode from Silas Marner* (90) of 1872. The former is painted with considerable vigour and decorative feeling, and the latter, showing Silas Marner (from George Eliot's novel) discovering the body of Godfrey Cass's wife in the snow, shows a slightly grotesque narrative forcefulness similar to that of his father.

Oliver Madox Brown:
Exercise 1870

89
Oliver Madox Brown:
Exercise 1870

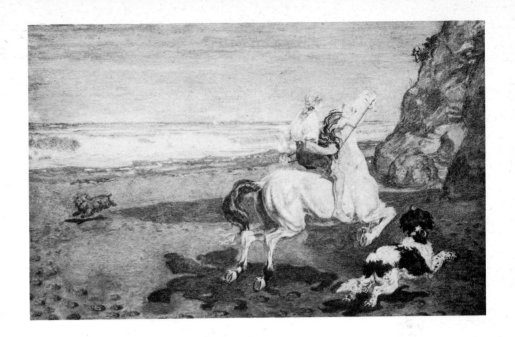

90
Oliver Madox Brown:
An episode from Silas Marner Exh. 1872

Millais' later work

In 1863 Millais was elected a member of the Royal Academy. As with so many Victorian artists, this led to the pursuit of easy popularity with a conservative picture-buying public which had plenty of money but little taste. Ruskin criticised Millais' change of style, so much worse after his early promise, as 'not merely Fall, but catastrophe'. And his late works were painted quickly and loosely, without the exquisite inventiveness and control that had marked his early work. Too many of them are dull portraits or sentimental subjects, lacking his former poetic intensity.

Nevertheless, his decline was not total, and *Stella* (91) of 1868 shows he still had considerable power. So different from the Pre-Raphaelite works, it is conceived in terms of rich handling, and strong light and shade, rather than the clear, shadowless colours of the earlier period. *Stella* is a fanciful recreation from eighteenth-century literature and foreshadows the late Victorian vogue for pretty costume pictures of the eighteenth century. Stella's real name was Esther Johnson, and she was a pupil and close friend of Swift, whose *Journal to Stella* consists of sixty-five letters to her, one of which she has been reading in the painting. Its contents must account for her mysterious and disturbing facial expression. A companion picture, showing Swift's other heroine *Vanessa* is at Sudley House, Liverpool.

In contrast, *A flood* (92) shows Millais at his most sentimental: the Victorians adored pictures of babies and of animals, and this work has always been a popular favourite. An early City Art Gallery catalogue strikes an authentic note: 'How delightful is the contrast between the joy of the child in birds and raindrops and the agony of fear in which the cat surveys the threatening waters.' Though painted at Windsor, in 1870, it was inspired by a real incident from a flood in Sheffield when, following the bursting of a reservoir, a child in its cradle was washed out of a house. The parents are seen coming to the rescue in the background. The baby was painted from Sophie, one of Millais' daughters, and the cat belonged to Fred Walker, an artist friend.

More serious is *Victory, O Lord!* (93) of the following year. Though in neither detail nor setting can it compare with the originality or earnestness of Hunt's religious paintings, it is still impressive. It shows the scene from Exodus when Moses, accompanied by Aaron and Hur, surveyed the battle between Joshua and the Amalekites from the top of a hill. 'And it came to pass, when Moses held up his

91
John Everett Millais:
Stella 1868

hand, that Israel prevailed: and when he let down his hand Amalek prevailed. But Moses' hands were heavy, and they took a stone and put it under him, and he sat thereon; and Aaron and Hur stayed up his hands, the one on the one side, and the other on the other side; and his hands were steady until the going down of the sun.'

Later in his career, Millais painted the portrait of a Jewish lady whose family, formerly called Moses, had anglicised their surname. When the portrait was shown, a critic wrote: 'Some years ago Mr. Millais painted a famous picture, "Moses, Aaron and Hur". This time we see he has painted her without Moses.'

From the late 1860s Millais built up a lucrative portrait practice and his facility at catching a likeness and summing up a character were much in demand. *Mrs Reiss*

123

92
John Everett Millais:
A flood 1870

of 1876 (94) is broadly, perhaps a little hastily handled, and emerges as a strong character. She and her husband Leopold, a Manchester merchant, were friends of Charles Hallé and helped to found the Hallé Orchestra. She was also the owner of *Victory, O Lord!*. *Bishop Fraser*, painted in 1880 (95) is a more spiritual likeness, and is not surrounded by worldly possessions. He was a notable Bishop of Manchester from 1870–1885, and was also portrayed in a bronze statue by Woolner in Albert Square, Manchester, dating from 1887. Woolner, one of the original members of the Pre-Raphaelite Brotherhood in 1848, had by this time become a proficient, if dull, sculptor of public monuments. The Albert Square figure is given additional interest by reliefs on the pedestal, alluding to his involvement in the co-operative and trades union movements. The reliefs show him with workers, visiting the sick, and blessing his congregation.

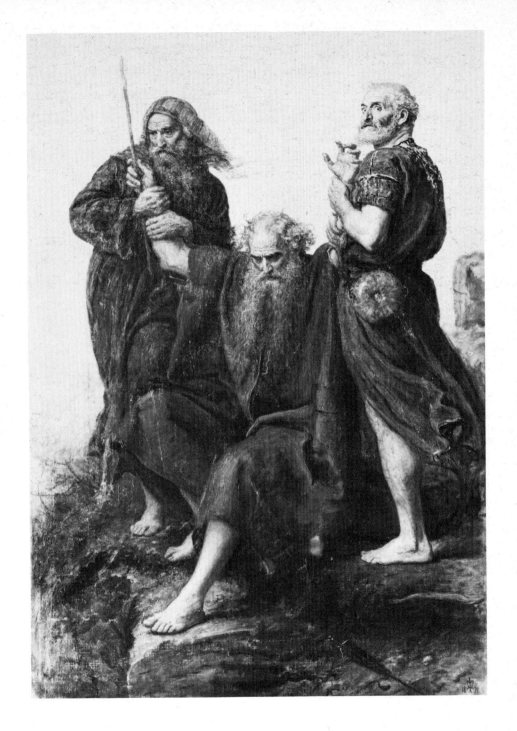

93
John Everett Millais:
Victory, O Lord! 1871

94
John Everett Millais:
Mrs Leopold Reiss 1876

95
John Everett Millais:
The Right Rev. James Fraser D.D.,
Lord Bishop of Manchester 1880

Winter fuel (96) of 1873 helps to disprove Ruskin's strictures: it is less moving than *Autumn leaves*, and lacks its fine touch, but is nevertheless a marvellously atmospheric piece of colour painting, the winter bleakness set off perfectly by the wisps of smoke in the background and the bright red of the girl's headscarf. The thick impasto which so well describes the tree trunks on the timber waggon shows that Millais could still paint superbly when he tried. It is a view of Birnam Hill, not far from Bowerswell, where *Autumn leaves* was painted. From the same area, but much later is *Glen Birnam* (97), a wintry landscape where the bleakness comes not so much from the colour, but from the note of sentimental pathos provided by the muffled figure walking along the snowy path under the leafless trees. The treatment is broad, but somewhat weak, lacking the rich paint surface of *Winter fuel*. Dating from 1891 it is one of a series of winter landscapes from the closing years of Millais' life. In February 1896 he was elected President of the Royal Academy, but died in August of the same year.

96
John Everett Millais:
Winter fuel 1873

97
John Everett Millais:
Glen Birnam 1891

Burne-Jones

Edward Coley Burne-Jones began as a follower of Rossetti, but evolved an independent style of such power and beauty that he deserves a section to himself. He fell under Rossetti's spell whilst he was at Oxford, and was one of the artists who worked on the Oxford Union murals. His early work is technically hesitant, but always highly imaginative. With maturity came technical control and a powerfully original sense of design which intensified his imaginative strength; his works convey an overwhelming sense of dreamlike beauty, purified of the worldliness and vulgarity sometimes evident in the work of his mentor. Burne-Jones created a world of his own, a claustrophobic world of softly glowing colours where tall, androgynous figures drift about, their impassive gazes hinting at a mysterious sadness, a world of deliberate unreality.

It is a curious quirk of history that pictures of this type are described by the same word, Pre-Raphaelite, which is applied to the hard, bright and colourful style of 1848; for the aims of the original Brotherhood are the opposite of Burne-Jones's definition of his art which serves to sum up the second phase of Pre-Raphaelitism. 'I mean by a picture,' he wrote, 'a beautiful romantic dream of something that never was, never will be, in a light better than any light that ever shone – in a land no-one can define or remember, only desire – and the forms divinely beautiful.'

The Sleeping Beauty (98) exemplifies this ideal: a gouache using gold paint on vellum, evidence at once of Burne-Jones' interest in craftsmanship and in medieval art, it shows a sleeping figure reclining decoratively on a couch in an architectural niche, amidst roses. When judged realistically, her pose is rather uncomfortable, but it makes a graceful design, and the picture manages to combine elements of real space and modelling with stylised linear patterns of flowers and drapery. The picture was commissioned by Murray Marks, the collector of blue and white china, in 1871: 'chinamania' was a craze started by Rossetti and his associates, on whom the subtle patterns and bold stylisation of Oriental art was a potent influence.

The Sleeping Beauty was a favourite theme of Burne-Jones. The story was first used in a set of tiles of the early 1860s and was later elaborated into the stunningly beautiful *Briar Rose* series, of which one version is in Puerto Rico (Museo Ponce) and the other installed as a frieze at Buscot Park, Berkshire (National Trust). These versions are larger in scale and have an even more pronounced elongation

and decoratively linear surface pattern.

Like the *Sleeping Beauty*, *Cupid and Psyche* (99) was a composition used in different forms. It was first designed in 1865 as one of a group of drawings for an illustrated edition of William Morris's *Earthly Paradise*. By 1887, when the design was taken up for this glowing watercolour, Burne-Jones had also used the compositions for a series of wall decorations in the dining-room of No. 1, Palace Green, Kensington, the home of George Howard, Earl of Carlisle, himself an amateur Pre-Raphaelite painter. The story comes from Apuleius' *The Golden Ass*, and the moment depicted is Cupid's first sight of Psyche, whom he was sent to destroy by Venus, jealous of Psyche's beauty. Psyche sleeps in a bower of roses, by a marble pool, in an atmosphere of hushed beauty. Both this and the preceding watercolour show sleeping women: sleep, dreams and states of trance-like stillness are frequent in Burne-Jones's work and must have exercised a compelling fascination for him.

Burne-Jones moved easily between different media, and produced decorative designs for furniture and textiles, tiles, stained glass and book illustration, as well as mural and easel pictures. The slight watercolour design of *Cherry blossom and fruit* (100) may be for a textile or embroidery, and the rather ugly *Head of Christ* (101) is a cartoon for mosaic. In 1881 Burne-Jones was commissioned to produce

98
Edward Burne-Jones:
The Sleeping Beauty 1871

99
Edward Burne-Jones:
Cupid and Psyche 1865–87

100
Edward Burne-Jones:
Cherry blossom and fruit

mosaics for the American Church in Rome, St Paul-within-the-walls, designed by G.E. Street. The cartoon, dating from around 1883 or 84, is a study for the figure of *Christ Enthroned*, which dominates the apsidal east end of the building (fig. xvii). The hard stylisation and odd proportions of the study are explained by the Byzantine formality of the mosaic.

More attractive as works of art are the pencil drawings which Burne-Jones produced in preparation for oil paintings. They combine a wonderful softness

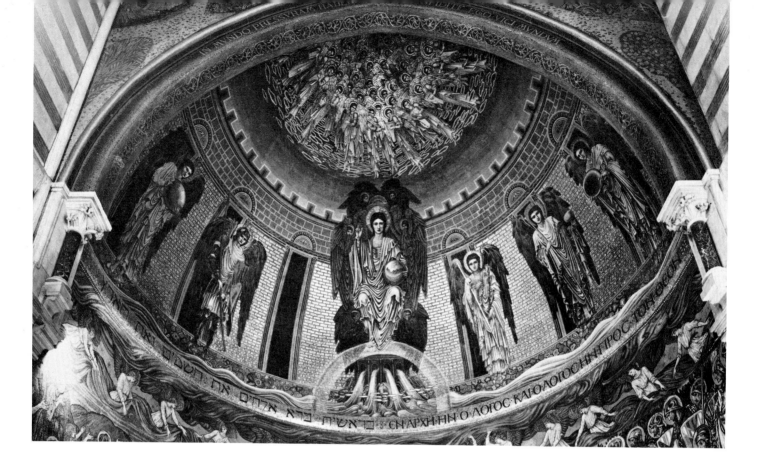

with a sense of form and a command of academic draughtsmanship unusual amongst the Pre-Raphaelites. The three *Studies of wings* (102–4), made presumably from dead birds, are related to the *Perseus* series, large panels showing the story of Perseus and Andromeda, commissioned by Arthur Balfour for the music room of 4 Carlton Gardens, London (now in the Staatsgalerie, Stuttgart, with cartoons at Southampton Art Gallery). The two studies dated 1882 relate to the scene of *The death of Medusa* (fig. xviii): Perseus has killed the Gorgon Medusa and escapes with her head, whilst her sisters circle wildly in the air, their wings beating. The other study, dated 1880, may also be for this scene, though it could be for another of the cycle, for feathery and scaly patterns run through all the episodes like an obsession, not only in the wings of the figures, or the hero's winged helmet and sandals, but in the shapes of his armour. Even the repeated lines of the drapery patterns take on an intricate feathery appearance. On the back of the 1880 study are two red chalk drawings of a nude female, possibly related to the *Perseus* series, though the vulgar and masculine face is uncharacteristic (105).

A similar use of patterning can be seen in one of Burne-Jones's most famous and elaborate paintings, *King Cophetua and the Beggar Maid* (Tate Gallery, fig. xix),

Fig. xvii
St Paul-within-the walls, Rome, showing the
mosaic *The Heavenly Jerusalem* by Edward
Burne-Jones

101
Edward Burne-Jones:
Head of Christ c. 1875

102
Edward Burne-Jones:
*Study of wing for 'The death of Medusa' in the
'Perseus' series* 1882

103
*Study of wing for 'The death of Medusa' in the
'Perseus' series* 1882

104
Study of a wing 1880

105
Two female figure studies

for which Manchester possesses three studies. The *Study of the drapery of the beggar maid* (106) shows great care and exactness; but in the finished picture the artist has preferred a simpler, more stylised pattern of folds. The reverse is true of the *Study of Cophetua* (107), for in the painting the king wears armour of a complex, feathery design. The third, a *Study for the hands of the beggar maid* (108) shows the simple, wild flowers held by the maid in deliberate contrast to the king's jewelled crown. The story is from Tennyson's poem about the beautiful beggar maid for whom the king gave up his throne and his wealth. From these first careful academic studies, Burne-Jones progressed towards the rich texture and inventive use of line and decoration which contributes so much to the atmosphere of the finished picture.

Fig. xviii
Edward Burne-Jones:
The death of Medusa, gouache

106
Edward Burne-Jones:
*Study of the drapery of the beggar maid for 'King
Cophetua and the Beggar Maid'* 1883

107
Edward Burne-Jones:
Study of Cophetua for 'King Cophetua and the Beggar Maid' c. 1883–4

108
Edward Burne-Jones:
Study of hands for 'King Cophetua and the Beggar Maid' c. 1883–4

Manchester's only large oil by Burne-Jones, *Sibylla Delphica* (109), is less complex, though no less characteristic of the artist. The Delphic Sibyl was the priestess of Apollo who presided over the oracle at Delphi. In her dreamlike trance she would interpret the answers of the oracle, and she is shown in typical Burne-Jones style, with mysterious and impassive features, standing in front of the sacrificial flame curling from her tripod, and holding the Apollonian laurel leaves. The Renaissance-style frame, classical architecture and facial type show the artist's admiration of Italian art, particularly that of Botticelli, who, like Burne-Jones, explored the decorative and expressive qualities of line, seen here particularly in the elaborate patterns made by the folds of drapery tied in such a curious way about the figure. The colour is soft and subtle, 'a study in tawny yellow' as *The Times* approvingly described the picture when it was shown in 1886 at the Grosvenor Gallery, showplace of the aesthetic school.

Burne-Jones's most important follower was his friend J. R. Spencer Stanhope, another of the group who worked on the Oxford Union murals. Stanhope's style owes a lot to that of Burne-Jones, yet Stanhope's colour is stronger and less subtle, his drawing is harder and in general the softness and stillness of his master is lacking. His choice of subject-matter and interest in technique is individual. *Eve tempted* (110), 1877, is a striking and slightly unnerving interpretation of the serpent in the Garden of Eden whispering into Eve's ear as she stands under the Tree of Knowledge, on a *faux-naïf* early Renaissance carpet of flowers. The large gilt gesso frame is of a type popular in Florence during the early Renaissance, and the technique, with its delicate lines and bright pasty colour is a careful revival of egg tempera, as practised by the Florentines.

Stanhope was in love with the Tuscan landscape and with Florentine art, and spent the latter part of his life in Florence. This influence is obvious on his large *The waters of Lethe* (111) of 1880, also painted in tempera. A measured procession of figures in stooping profile, some young, some old, passes across the foreground across barren rocks, towards the river of forgetfulness. Some go in fear, some in resignation, others longing for the escape from worldly care. At the other side they emerge, cleansed and reborn, to dance in the Elysian Fields, amidst flowers and trees. In the background is the heavenly city of Florence, surrounded by a golden radiance. Despite a certain hardness in the drawing, and a lurid brightness of colour, the picture is impressive both as allegory and as an attempt to recreate the Florentine style; but it lacks the subtle magic of the enchanted world of Burne-Jones.

There remain two pictures, both showing the influence of Burne-Jones. The first is the well-known *Hylas and the nymphs* (112) by J. W. Waterhouse, painted in 1896. The artist began painting classical scenes somewhat in the manner of Alma-Tadema, though with a broader technique and a rather shallow sensationalism. He later adopted a more Pre-Raphaelite manner, employing richer colours and a sweet, wistful female type derived from the *femmes fatales* of Rossetti and Burne-Jones. *Hylas and the nymphs*, with its glowing greens and blues and long-haired

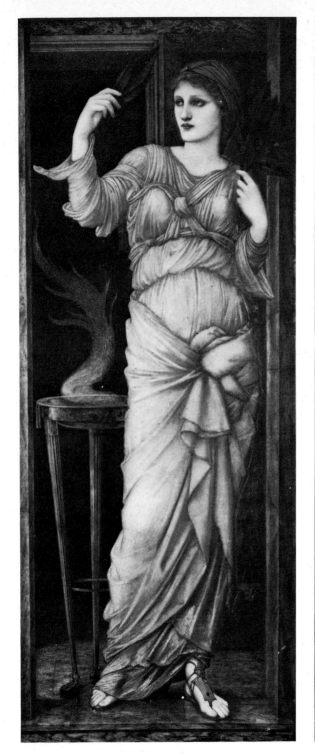

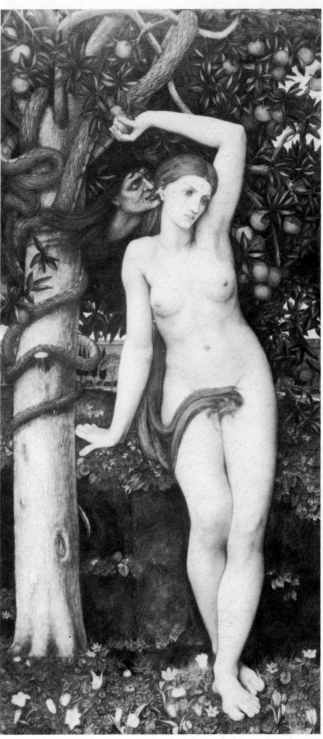

109
Edward Burne-Jones:
Sibylla Delphica Exh. 1886.

110
J. R. Spencer Stanhope:
Eve tempted Exh. 1877

137

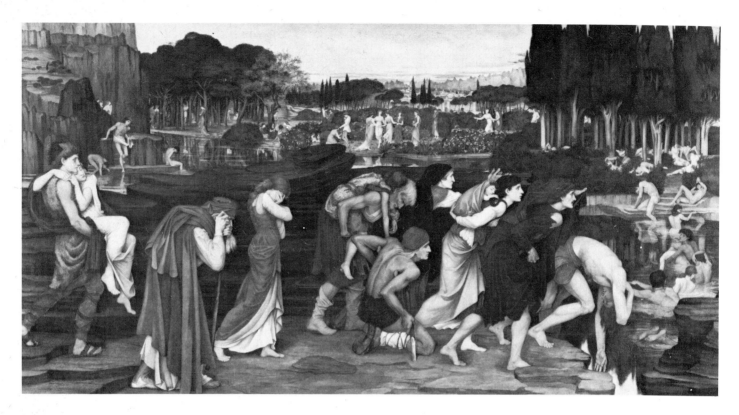

111
J.R.Spencer Stanhope:
The waters of Lethe by the plains of Elysium
Exh. 1880

maidens is a typical mixture of classical myth and Rossetti figure types. The myth comes from Homer's *Odyssey*: Hylas was one of the Argonauts, companions of Hercules. When they reached the coast of Troad, Hylas went ashore in search of water, and discovered a spring inhabited by nymphs, whose nourishment of ambrosia kept them always young and beautiful. The nymphs lured Hylas into the water and he was never heard of again. Waterhouse has turned the story of pagan brutality and watery death into a pretty fairy tale. The nymphs appear as nubile, sweet-eyed adolescents rather than predators embodying the forces of nature. The painting has become memorable through frequent exhibition, and because of its mild eroticism; Waterhouse has tailored Pre-Raphaelite ingredients to the middle-brow demands of the mass public who saw it not only at the Royal Academy but at several international exhibitions held at the turn of the century. It is a striking image, but slightly superficial: somehow it does not quite touch the depths of the imagination.

Ten years after *Hylas* was painted, J.M.Strudwick, a former studio assistant of Burne-Jones and Stanhope, showed *When apples were golden and songs were sweet, But summer had passed away* (113). A diluted version of a Burne-Jones, it has all the outward hallmarks of his style: sweet, sad faces, a touch of medievalism, a feeling for rich texture and detail, linear patterning in the draperies. But it lacks the compelling imaginative force which in Burne-Jones makes sense of the detail, a

force which gives Burne-Jones's best work the haunting inevitability of a dream.

In such works as these, the achievement of Burne-Jones and Rossetti was watered down, and a new orthodoxy emerged. Burne-Jones's work was not orthodox; even when he was at the height of his fame, his work always had something deeply disturbing about it, a kind of inner sadness. He exhibited at the Academy twice, and reluctantly accepted its Associateship, but did not feel happy in such an official body, and resigned soon afterwards. On the other hand, Waterhouse happily became an RA and regularly exhibited pictures of a safe and undemanding kind, pretty but shallow. Similarly, Strudwick carried on producing pale echoes of Burne-Jones long after the inner force had evaporated from the style. In the shadow of artists like these, a generation of art students was brought up to think in terms of drooping maidens and fanciful classical or medieval allegory.

Artists working in this late, aesthetic version of Pre-Raphaelitism were unworthy heirs to the Brotherhood of 1848, who were against anything conventional or learned by rote. Yet in one respect at least the Brotherhood had contributed to a change in the English art scene, for by 1900, the Royal Academy

112
J. W. Waterhouse:
Hylas and the nymphs 1896

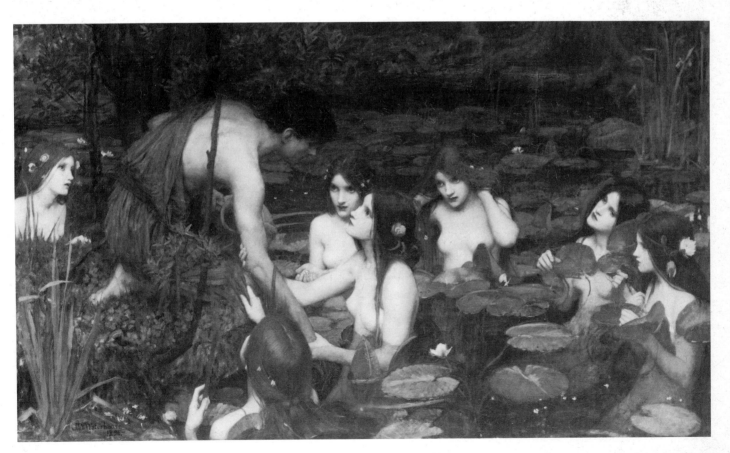

no longer held a dictatorial position over English taste as it had done in 1848. Members of the Pre-Raphaelite circle had organised their own exhibitions, either group exhibitions or one man shows, and had also sold pictures privately to discerning patrons. In the 1870s and 80s the emergence of such exhibiting bodies as the Grosvenor Gallery, and the New English Art Club had ensured that there were places where advanced and unconventional work could be publicly displayed. This was at least in part due to the attack by the Pre-Raphaelites on the Academy.

The Pre-Raphaelite tradition lingered on well into the twentieth century, and in some of its practitioners it retained a certain integrity, but fashion in art left it well behind. Progressive artists were no longer interested in a high degree of finish, or in literary painting, or in medievalism; Impressionism, Post-Impressionism, and Modernism arrived, and the Pre-Raphaelites appeared a quaint, eccentric joke. But today, after a resurgence of research and exhibitions, their seriousness is no longer questioned. Their achievement contains contradictions probably present in embryo right at the beginning: they looked at modern life, yet they looked back to medieval legend; they looked hard at the outward forms of nature, yet they turned introspectively towards the inner world of the emotions and the imagination; they copied what they saw around them, yet they were inspired by earlier masters, and were determined to incorporate in their style a sense of material beauty and craftsmanship; they aspired to individuality, yet created a new fashionable convention. In different artists and at different times, some of these facets were more predominant than others. Yet at best they triumphantly fulfilled two of the aims on William Michael Rossetti's original list: to have genuine ideas to express, and to produce thoroughly good pictures.

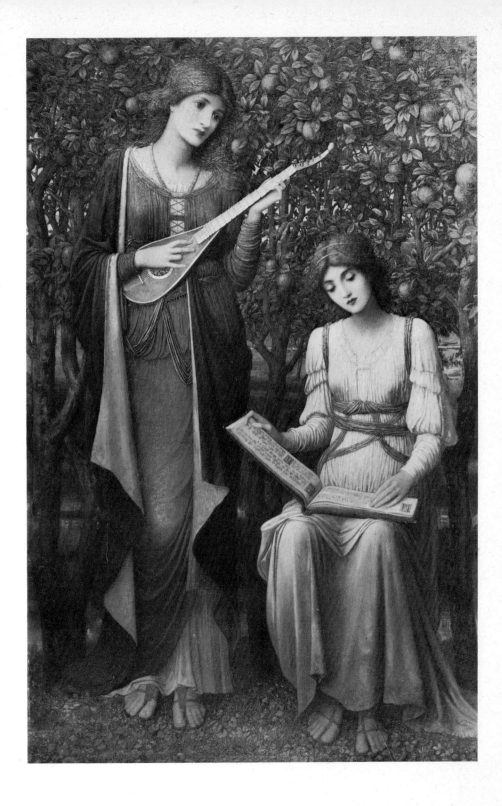

Select bibliography

For the general reader, a number of good recent introductions are available. The best of these are:

William Gaunt, *The Pre-Raphaelite Tragedy*, 1942, reissued paperback 1975
Timothy Hilton, *The Pre-Raphaelites*, 1970
John Nicoll, *The Pre-Raphaelites*, 1970
Andrea Rose, *The Pre-Raphaelites*, 1977
Raymond Watkinson, *Pre-Raphaelite Art and Design*, 1970

For a complete bibliography to 1965 the serious student should refer to the indispensable *Pre-Raphaelitism: A Biblio-Critical Study* by W.E.Fredeman, 1965. Only a selection of more recent studies and exhibition catalogues are listed here.

Oswald Doughty, *A Victorian Romantic: Dante Gabriel Rossetti*, 1960
Penelope Fitzgerald, *Sir Edward Burne-Jones*, 1975
A.I.Grieve, *The Art of Dante Gabriel Rossetti*:
No. 1, *The Pre-Raphaelite Period*, 1973
No. 2, *Found* and *The Pre-Raphaelite Modern Life Subject*, 1976
No. 3, *The Watercolours and Drawings of 1850–1855*, 1979
(Further volumes forthcoming)
Martin Harrison and Bill Waters, *Burne-Jones*, 1973
Philip Henderson, *William Morris, His Life, Work and Friends*, 1967
George Landow, *William Holman Hunt and Typological Symbolism*, 1979
Allen Staley, *The Pre-Raphaelite Landscape*, 1973
Virginia Surtees, *D.G.Rossetti: The Paintings and Drawings* (two volumes), 1971

Exhibition catalogues:
Ford Madox Brown, Walker Art Gallery, Liverpool, 1964
(catalogue by Mary Bennett)
Burne-Jones, Mappin Art Gallery, Sheffield, 1971
(catalogue by W.S.Taylor)
Burne-Jones, Hayward Gallery, London, 1975–6
(catalogue by John Christian)

William Holman Hunt, Walker Art Gallery, Liverpool, 1969
(catalogue by Mary Bennett)
Sir John Everett Millais, Walker Art Gallery, Liverpool, 1967
(catalogue by Mary Bennett)
Dante Gabriel Rossetti, Royal Academy, 1973
(catalogue by Virginia Surtees)
Frederick Sandys, Brighton Art Gallery, 1974
(catalogue by Betty O'Looney)

Catalogue of works at Manchester City Art Gallery

Arrangement of entries

Works are arranged by artist, in alphabetical order, and then in accession order. Some works have formerly been known under other titles: these are given, but the more authentic or accurate titles are given first.

Dates

If a work can be securely dated by documentary evidence, the date is given on its own. Otherwise abbreviations are used:

c. circa, for an approximate dating on stylistic or other grounds
Exh. date of first exhibition
publ. date of first publication in the case of drawings for book illustrations

Medium and support

Only the immediate support is given.

Dimensions

Sizes for both oil paintings and drawings are given in centimetres, and followed in brackets by inches to the nearest sixteenth. Height precedes width. Dimensions given are those of the original painted surface, not of any additional supporting canvas, panel or mount. A sight measurement is indicated if the full measurements cannot be taken.

Signature and inscriptions

These are recorded in full:

s: signed
inscr: inscribed, for inscriptions in the artist's hand
(blc) bottom left corner
(tr) top right etc.
(mon) following a signature, denotes that the initials form an artist's monogram

Signatures and inscriptions are given in italics. An oblique stroke is used to indicate the beginning of a fresh line in an inscription.

Provenance

Only the immediate source of each work is given.

James Archer 1824–1904

43, p. 77
Thomas de Quincey 1903
Oil on canvas
102·7 × 86·5 ($40\frac{7}{16}$ × $34\frac{1}{16}$)
s(brc): *JA/1903* (mon)
Purchased (1904.3)

42, p. 76
La Mort d'Arthur 1860
Oil on millboard
43·2 × 50·9 (17 × 20)
s(bl on cloak): *18 JA 60* (mon)
Miss L. A. Haworth gift in memory of
Lady Haworth (1952.252)

John Brett 1830–1902

51, p. 82
The Norman Archipelago 1885
Oil on canvas
107·2 × 214 ($42\frac{3}{16}$ × $84\frac{1}{4}$)
s(blc): *John Brett 1885*
Purchased (1885.25)

50, p. 82
Seascape 1881
Oil on canvas
17·8 × 35·6 (7 × 14)
Unsigned. Inscr(tlc): (?) *Trevose Head
June 7. 81*
Horsfall Museum transfer (1918.414)

Ford Madox Brown 1821–1893

27, p. 55, 57 + colour plate IV, p. 16
Work 1852–65
Oil on canvas, arched top
137 × 197·3 ($53\frac{15}{16}$ × $77\frac{11}{16}$)
s(brc): *F. MADOX BROWN 1852–/65.*
(in one line)
Purchased (1885.1)

30, p. 61
Preliminary study for 'Work' 1852?–64
Watercolour and pencil on paper, arched top
19·7 × 28 ($7\frac{3}{4}$ × 11)
s(brc): *FMB* (mon)
Purchased (1893.23)

11, p. 29
William Shakespeare 1849
Oil on canvas
135·6 × 87·5 ($53\frac{3}{8}$ × $34\frac{7}{16}$)
Unsigned
Purchased (1900.16)

26, p. 52
Jesus washing Peter's feet 1876
Watercolour on paper
48·6 × 54·8 ($19\frac{1}{8}$ × $21\frac{9}{16}$)
s(brc): *FMB – 76* (mon)
Lieut.-Col. H. J. Candlin gift (1901.11)

80, p. 114
Cromwell, Protector of the Vaudois 1877
Oil on canvas
86 × 107 ($33\frac{7}{8}$ × $42\frac{1}{8}$)
s(blc): *FMB – 77* (mon)
Lieut.-Col. H. J. Candlin gift (1901.12)

6, p. 25
**The body of Harold brought before
William the Conqueror (Wilhelmus
Conquistator)** 1844–61
Oil on canvas
105 × 123·1 ($41\frac{5}{16}$ × $48\frac{7}{16}$)
s(blc): *F. MADOX BROWN 1844–61*
Purchased (1907.9)

34, p. 67
Stages of cruelty 1856–90
Oil on canvas
73·3 × 59·9 (28$\frac{7}{8}$ × 23$\frac{9}{16}$)
s(blc): *FMB – 56/ – 90* (mon)
Purchased (1911.105)

3, p. 23
The Prisoner of Chillon 1843
Oil on canvas
53·2 × 64·9 (20$\frac{15}{16}$ × 25$\frac{9}{16}$)
Unsigned
Harold Rathbone gift (1911.107)

4, p. 24
Dr Primrose and his daughters
Oil on canvas
72·6 × 58·7 (28$\frac{9}{16}$ × 23$\frac{1}{8}$)
Unsigned
Purchased (1912.61)

1, p. 21
Rev. F.H.S.Pendleton 1837
Oil on panel
16·9 × 13·3 (6$\frac{5}{8}$ × 5$\frac{1}{4}$)
s(brc): *F.M.BROWN/à son ami/*. . . (illegible)
Purchased (1913.10)

2, p.
Manfred on the Jungfrau 1840–61
Oil on canvas
140·2 × 115 (55$\frac{3}{16}$ × 45$\frac{1}{4}$)
s(brc): *Ford Madox Brown*
F.W. Jackson gift (1916.13)

78, p. 112
Cordelia's portion 1869
Pencil, ink, crayon, chalk and wash on paper
74·5 × 107 (29$\frac{5}{16}$ × 42$\frac{1}{8}$)
s(blc): *FMB – 69* (mon)
E.G.Francis bequest (1917.274)

87, p. 119
Ford Madox Hueffer 1885
Coloured chalks on paper
35·2 × 35·3 (13$\frac{7}{8}$ × 13$\frac{15}{16}$)
s(brc): *FMB – 85* (mon)
Horsfall Museum transfer (1918.1018)

86, p. 118
Study for 'Madeline Scott' c. 1883
Coloured chalks on paper
35·2 × 35·6 (13$\frac{7}{8}$ × 14)
s(trc): *FMB* (mon)
inscr(tlc) *MADELINE SCOTT*
Horsfall Museum transfer (1918.1019)

31, p. 62
Study of the Rev. F.D.Maurice and Thomas Carlyle for 'Work' 1858
Pencil on paper
83 × 45·3 (32$\frac{11}{16}$ × 17$\frac{13}{16}$)
Unsigned
Purchased (1922.21)

28, p. 60
Heath Street, Hampstead (Study for 'Work') 1852–5
Oil on canvas, arched top
22·8 × 30·8 (9 × 12$\frac{1}{8}$)
Unsigned
Purchased (1924.30)

54, p. 87
The traveller 1868–84
Oil on panel
31·6 × 48·6 (12$\frac{7}{16}$ × 19$\frac{1}{8}$)
s(brc): *FMB – 84* (mon)
Purchased (1925.83)

7, p. 26
Study for 'The Spirit of Justice' 1845
Pencil, watercolour and bodycolour on paper, arched top
75·7 × 51·7 (29$\frac{13}{16}$ × 20$\frac{3}{8}$)
Unsigned
A.Campbell Blair gift (1925.94)

55, p. 87
The Corsair's return 1860
Crayon on paper
23·5 × 38·4 (9$\frac{1}{4}$ × 15$\frac{1}{8}$) sight
s(brc): *FMB – 60* (mon)
Thomas Smith gift (1930.76)

9, p. 29
Study of a courtier for 'Chaucer at the Court of Edward III' 1848
Oil on millboard
60·9 × 46·6 (24 × 18$\frac{5}{16}$)
Unsigned
Sir Michael E.Sadler gift, in memory of Lady Sadler, through the N.A–C.F. (1931.21)

35, p. 67
The English boy (Oliver Madox Brown) 1860
Oil on canvas
39·6 × 33·3 (15$\frac{9}{16}$ × 13$\frac{1}{8}$)
s(trc): *F.MADOX BROWN/60* (in one line)
C.P.Scott bequest (1932.10)

85, p. 118
Madeline Scott 1883
Oil on canvas
122·1 × 78·5 (48$\frac{1}{16}$ × 30$\frac{7}{8}$)
s(brc): *FMB – 83* (mon)
C.P.Scott bequest (1932.14)

88, p. 119
Charles Rowley, Junr. 1855
Coloured chalks on paper
49·2 × 43·1 (19$\frac{3}{8}$ × 17)
s(trc): *FMB – 85* (mon)
Inscr(tlc): *CHARLES ROWLEY JUN*R
Mrs A.Amy Brooke gift (1936.116)

10, p. 29
Two studies of a little girl's head (Millie Smith; formerly Two children) 1847
Oil on linen
35·6 × 45·8 (14 × 18)
s(brc): *F.Madox Brown. 1847.*
G. Beatson Blair bequest 1941 (1947.70)

84, p. 117
John Kay, inventor of the flying shuttle, 1753 (unfinished) 1888
Tempera on panel
35·4 × 78·8 (13$\frac{15}{16}$ × 31)
Unsigned
G.Beatson Blair bequest 1941 (1947.81)

79, p. 113
Byron's dream 1874
Oil on canvas
71·5 × 54·8 (28$\frac{1}{8}$ × 21$\frac{9}{16}$)
s(brc): *FMB – 74* (mon)
G.Beatson Blair bequest 1941 (1947.82)

82, p. 116
The proclamation regarding weights and measures, 1556 1889
Tempera on panel
26·2 × 56·9 (10$\frac{5}{16}$ × 22$\frac{3}{8}$)
s(blc): *FMB Nov – 89* (mon)
G.Beatson Blair bequest 1941 (1947.85)

81, p. 116
The establishment of the Flemish weavers in Manchester, 1363 1888
Tempera on panel
27·1 × 55·9 (10$\frac{5}{8}$ × 22)
s(blc): *FMB – 88* (mon)
G.Beatson Blair bequest 1941 (1947.86)

83, p. 117
Crabtree watching the transit of Venus, 1639 1881–8
Tempera on panel
26·4 × 55·9 (10⅜ × 22)
s(brc): *FMB – 81 – 88* (mon)
G. Beatson Blair bequest 1941 (1947.87)

33, p. 65
Out of town 1843–58
Oil on canvas
23·2 × 14·4 (9⅛ × 5¹¹⁄₁₆)
s(on bench, r): *FMB – 58* (mon)
G. Beatson Blair bequest 1941 (1947.94)

5, p. 24
Family group (The Bromley family) 1844
Oil on canvas
117·4 × 81·1 (46³⁄₁₆ × 31¹⁵⁄₁₆)
(s(br): *F.M.BROWN/1844*
G. Beatson Blair bequest 1941 (1947.142)

29, p. 60
First rough sketch for 'Work' 1856
Pencil on paper
27·8 × 39·7 (10¹⁵⁄₁₆ × 15⅝)
inscr: *First rough sketch for/"Work"/Hampstead/56*
Purchased with the aid of a grant from the Victoria & Albert Museum (1965.310)

8, p. 26
Fragment of 'The Spirit of Justice' 1844–5
Charcoal on paper
77·2 × 50·7 (30⅜ × 20)
Unsigned
Purchased (1966.294)

32, p. 63
Study of the beer-drinking navvy for 'Work'
Charcoal on paper, cut to silhouette
irregular, 39·4 × 21·2 (15½ × 9½)
Unsigned
Purchased (1978.91)

Oliver Madox Brown 1855–1874

89, p. 121
Exercise 1870
Watercolour and gouache on paper
32 × 51·8 (12⅝ × 20⅜)
s(brc): *OMB – 70* (mon)
Purchased (1947.7)

90, p. 121
An episode from 'Silas Marner' (Silas Marner finding the body of Godfrey Cass's wife) Exh. 1872
Watercolour mixed with size on paper
45·7 × 56 (18 × 22¹⁄₁₆)
s(brc): *OMB 72A* (?) (mon)
Mrs Heatley gift (1960.304)

William Burges 1827–81
and Gualbert Saunders fl. 1865–80

61, p. 94 + in colour on back cover
Escritoire 1865–7
Painted wood with ceramic tiles and brass fittings
height 257·8 (101½)
Purchased (1979.132)

Edward Coley Burne-Jones
1833–1898

109, p. 137
Sibylla Delphica Exh. 1886
Oil on panel
152·8 × 60·3 (60⅛ × 23¾)
s(br on pier): *E.B.J.* (mon)
Purchased (1886.5)

98, p. 130
The Sleeping Beauty 1871
Watercolour and gold paint on vellum
27 × 37·6 (10⅝ × 14¹³⁄₁₆)
s(blc): *E.Burne Jones./MDCCCLXXI*
James Blair bequest (1917.15)

99, p. 131
Cupid and Psyche 1865–87
Watercolour with bodycolour and gold paint on paper
64·9 × 49·4 (25⁹⁄₁₆ × 19⁷⁄₁₆)
s(blc): *E.B.J.* Inscr on blackboard: *designed. 1865. E.BURNE-JONES. finished 1887*
James Blair bequest (1917.16)

100, p. 131
Cherry blossom and fruit
Watercolour on paper
42·1 × 50·6 (16⁹⁄₁₆ × 19¹⁵⁄₁₆)
Unsigned
Horsfall Museum transfer (1918.466)

103, p. 133
Study of wing for 'The Death of Medusa' in the 'Perseus' series 1882
Pencil on paper
31·6 × 21·1 (12⁷⁄₁₆ × 8⁵⁄₁₆)
s(blc): *EB-J/ 1882* Inscr: *WINGS FOR THE/DEATH OF/MEDUSA in/PERSEUS series*
C.L. Rutherston gift (1925.137a)

102, p. 133
Study of wing for 'The Death of Medusa' in the 'Perseus' series 1882
Pencil on paper
31·1 × 19·9 (12¼ × 7¹³⁄₁₆)
s(blc): *EBJ./1882*
C.L. Rutherston gift (1925.137b)

107, p. 136
Study of Cophetua for 'King Cophetua and the Beggar Maid' c. 1883–4
Pencil on paper
21·8 × 16·5 (8⁹⁄₁₆ × 6½) sight
Unsigned
C.L. Rutherston gift (1925.143a)

108, p. 136
Study of hands for 'King Cophetua and the Beggar Maid' c. 1883–4
Pencil on paper
21·8 × 16·5 (8⁹⁄₁₆ × 6½) sight
Unsigned
C.L. Rutherston gift (1925.143b)

101, p. 132
Head of Christ (Study for mosaic in the American Protestant Church, Rome)
c. 1875
Watercolour on card
68·8 × 54·9 (27⅛ × 21⅝)
Unsigned
C.L. Rutherston gift (1925.163)

104, p. 133
Study of a wing 1880
Pencil on paper
32·6 × 21·4 (12¹³⁄₁₆ × 8⁷⁄₁₆)
s(blc): *EBJ/1880*
C.L. Rutherston gift (1925.483)

105, p. 133
Two female figure studies (verso of above)

106, p. 135
Study of the drapery of the beggar maid for 'King Cophetua and the Beggar Maid'
1883
Pencil on paper
35·5 × 25 (14 × 9¹³⁄₁₆)
s(blc): *EBJ/1883*
C.L. Rutherston gift 1925

Charles Allston Collins 1828–1873

13, p. 33 + colour plate I, p. 13
Berengaria's alarm for the safety of her husband, Richard Cœur de Lion, awakened by the sight of his girdle offered for sale at Rome (formerly **The Pedlar**)
1850
Oil on canvas
101·2 × 106·7 (39$\frac{7}{8}$ × 42)
s(br): *CHARLES COLLINS 1850*
Purchased (1896.1)

James Collinson 1825–1881

14, p. 34
Answering the emigrant's letter 1850
Oil on panel
70·1 × 91·2 (27$\frac{5}{8}$ × 35$\frac{7}{8}$)
s(brc): *J. Collinson. 1850.*
Purchased (1966.179)

Arthur Hughes 1832–1915

57, p. 89
The youngest child's death (formerly **The mother's vigil; for 'Enoch Arden'**, publ. 1866)
Ink on paper
23·2 × 33·5 (9$\frac{1}{8}$ × 13$\frac{3}{16}$)
s(brc): *AH* (mon)
Lloyd Roberts bequest (1920.666)

58, p. 89
The shipwreck island (formerly **Stags; for 'Enoch Arden'**, publ. 1866)
Ink on paper
21·5 × 31·5 (8$\frac{7}{16}$ × 12$\frac{3}{8}$)
s(brc): *AH* (mon)
Lloyd Roberts bequest (1920.680)

56, p. 88
Enoch's farewell (formerly **The labourer's return; for 'Enoch Arden'**, publ. 1866)
Ink on paper
30·3 × 24·2 (11$\frac{15}{16}$ × 9$\frac{1}{2}$)
s(brc): *AH* (mon)
Lloyd Roberts bequest (1920.681)

17, p. 39 + colour plate II, p. 14
Ophelia 1852
Oil on canvas
68·7 × 123·8 (27$\frac{1}{16}$ × 48$\frac{3}{4}$)
s(brc): *ARTHUR HUGHES*
Purchased (1955.109)

William Holman Hunt 1827–1910

38, p. 71 + colour plate VI, p. 18
The Shadow of Death 1870–3
Oil on canvas
214·2 × 168·2 (84$\frac{5}{16}$ × 66$\frac{3}{16}$)
s(brc): *18 Whh 70–3/ JERUSALEM* (mon)
Thomas and William Agnew gift (1883.21)

16, p. 38 + in colour on front cover
The Hireling Shepherd 1851
Oil on canvas
76·4 × 109·5 (30$\frac{1}{16}$ × 43$\frac{1}{8}$)
s(blc): *Holman Hunt. 1851. Ewell*
Purchased (1896.29)

37, p. 70 + colour plate V, p. 17
The Scapegoat 1854–5
Oil on canvas
33·7 × 45·9 (13$\frac{1}{4}$ × 18$\frac{1}{16}$)
s(blc): *Whh* (mon)
Purchased (1906.2)

18, p. 41
The Light of the World 1851–6
Oil on canvas
49·8 × 26·1 (19$\frac{5}{8}$ × 10$\frac{5}{16}$)
s(brc): *Whh* (mon)
Purchased (1912.53)

40, p. 73
Study: sunset
Watercolour with bodycolour on paper
17 × 12·3 (6$\frac{11}{16}$ × 4$\frac{7}{8}$)
s(blc): *Whh* (mon)
James Blair bequest (1917.29)

36, p. 68
The lantern maker's courtship c.1854–60
Oil on panel
29·4 × 18·8 (11$\frac{9}{16}$ × 7$\frac{3}{8}$)
s(blc): *Whh* (mon)
James Gresham bequest (1917.266)

39, p. 72
Study of a head (Edith Holman Hunt)
1884
Oil on panel
33·5 × 30·7 (13$\frac{3}{16}$ × 12$\frac{1}{16}$)
s(blc): *W.H.H. 84. to his old friend Dr. Q . . . (illegible)/Painted on Gesso M . . . (illegible)*
Purchased (1920.6)

15, p. 36
Dante Gabriel Rossetti 1853
Coloured chalks on paper, oval
28·6 × 25·9 (11$\frac{1}{4}$ × 10$\frac{3}{16}$)
s(brc): *W. Holman Hunt/to his PR Brother/ T Woolner/April 12*
Purchased (1922.25)

52, p. 85
The Lady of Shalott c.1886–1905
Oil on panel
44·4 × 34·1 (17$\frac{1}{2}$ × 13$\frac{7}{16}$)
s(blc): *Whh* (mon)
John E. Yates bequest (1934.401)

53, p. 86
Hercules in the Garden of the Hesperides 1887
Painted plaster, oval
69·2 × 52 (27$\frac{1}{4}$ × 20$\frac{1}{2}$)
Unsigned
Mrs Joseph (née Hunt) gift (1943.54)

Robert Braithwaite Martineau 1826–1869

48a, p. 81
Study of a woman's head
Pencil on paper
13·9 × 19 (5$\frac{1}{2}$ × 7$\frac{1}{2}$) sight
Unsigned
Miss Helen Martineau bequest (1951.8a)

48b, p. 81
Study of a man's head
Pencil on paper
13·2 × 16·7 (5$\frac{3}{16}$ × 6$\frac{9}{16}$) sight
Unsigned
Miss Helen Martineau bequest (1951.8b)

48c, p. 81
Study of a woman's head, looking down
Pencil on paper
14·2 × 19·2 (5$\frac{9}{16}$ × 7$\frac{9}{16}$) sight
Unsigned
Miss Helen Martineau bequest (1951.8c)

47, p. 80
Study for 'A woman of San Germano' (formerly **Study of a woman holding a baby**) c.1864
Oil on canvas
44·7 × 37·4 (17$\frac{9}{16}$ × 14$\frac{3}{4}$)
Unsigned
Miss Helen Martineau bequest (1951.9)

49, p. 81
The artist's wife in a red cape
Oil on canvas
35·5 × 27·9 (14 × 11)
Unsigned
Miss Helen Martineau bequest (1951.10)

John Everett Millais 1829–1896

92, p. 124
A flood 1870
Oil on canvas
99·3 × 144·9 (39⅛ × 57 1/16)
s(brc): *18 JM 70* (mon)
Purchased (1891.7)

24, p. 50 + colour plate III, p. 15
Autumn leaves 1856
Oil on canvas
104·3 × 74 (41 1/16 × 29⅛)
s(brc): *18 JM 56* (mon)
Purchased (1892.4)

93, p. 125
Victory, O Lord! 1871
Oil on canvas
194·7 × 141·3 (76⅝ × 55⅝)
s(brc): *18 JM 71* (mon)
Purchased (1894.1)

96, p. 127
Winter fuel 1873
Oil on canvas
194·5 × 149·5 (76 9/16 × 58⅞)
s(brc): *18 JM 73* (mon)
G. B. Worthington gift (1897.4)

91, p. 123
Stella 1868
Oil on canvas
112·7 × 92·1 (44⅜ × 36¼)
s(brc): *18 M 68* (mon)
Purchased (1908.12)

97, p. 128
Glen Birnam 1891
Oil on canvas
145·2 × 101·1 (57⅛ × 39 13/16)
s(brc): *John E Millais/1891*
Mrs E. A. Rylands bequest (1908.15)

22, p. 48
Wandering thoughts
(formerly **Mrs Charles Freeman**) c.1855
35·2 × 24·9 (13⅞ × 9 13/16)
s(brc): *J E Millais*
Purchased (1913.28)

25, p. 51
Study for 'The Vale of Rest' c.1858
Watercolour mixed with gum, and bodycolour
on paper
12 × 20 (4¾ × 7⅞) sight
s(brc): *M* (mon)
James Blair bequest (1917.31)

23, p. 48
Only a lock of hair c.1857–8
Oil on panel
35·3 × 25 (13⅞ × 9⅞)
s(blc): *M* (mon)
James Gresham bequest (1917.268)

94, p. 126
Mrs Leopold Reiss 1876
Oil on canvas
122 × 95 (48 × 37⅜)
s(blc) *18 JM 76* (mon)
Mrs Everard Hopkins gift (1932.1)

12, p. 32
The Death of Romeo and Juliet c.1848
Oil on millboard
16·1 × 26·9 (6 5/16 × 10⅝)
s(brc): *JEM* (mon)
G. Beatson Blair bequest 1941 (1947.89)

95, p. 126
**The Right Rev. James Fraser D.D.,
Lord Bishop of Manchester** 1880
Oil on canvas
128 × 93·6 (50⅜ × 36 13/16)
s(brc): *18 JM 80* (mon)
Mrs Fraser bequest to the Town Hall 1895;
transferred to the City Art Gallery 1979
(1979.134)

Valentine Cameron Prinsep
1838–1904

63, p. 96
At the Golden Gate Exh. 1882
Oil on canvas
137·5 × 95·8 (54⅛ × 37 11/16)
Unsigned
W. A. Turner gift (1883.22)

62, p. 95
Cinderella Exh. 1899
Oil on canvas
149·6 × 113·1 (58⅞ × 44½)
Unsigned
Mrs E. A. Rylands bequest (1908.17)

60, p. 94
**The queen was in the parlour,
Eating bread and honey** Exh. 1860
Oil on panel
59·6 × 33 (23½ × 13)
s(brc): *VCP* (mon)
Purchased (1938.487)

Dante Gabriel Rossetti 1828–1882

75, p. 110
Astarte Syriaca 1877
Oil on canvas
185 × 109 (72 13/16 × 42 15/16)
s(blc): *D. G. Rossetti. 1877.*
Purchased (1891.5)

73, p. 108
La donna della fiamma 1870
Coloured chalks on paper
101·8 × 71·1 (40 1/16 × 30)
s(brc): *DGR 1870*
Inscr(tr): *La Donna della Fiamma*
Purchased (1900.11)

70, p. 106 + colour plate VIII, p. 20
The bower meadow 1850–72
Oil on canvas
86·3 × 68 (34 × 26¾)
s(blc): *D G Rossetti/ 1872*
Purchased (1909.15)

74, p. 109
Study for 'The Blessed Damozel' 1876
Coloured chalks on paper
54·9 × 56·5 (21⅝ × 22¼)
s(brc): *DGR 1876* (mon)
Inscr(trc): *head-study for Picture,/"The Blessed
Damozel."*
Horsfall Museum transfer (1918.1020)

20, p. 45
Dante meeting Beatrice 1864
Coloured chalks on millboard
31·1 × 26 (12¼ × 10¼)
s(brc): *DGR 1864* (mon)
Inscr(blc): *Guardami ben: ben son, ben son Beatrice*
Lloyd Roberts bequest (1920.626)

71, p. 107
Study for 'Pandora' (formerly **Head of a
lady**) 1869
Coloured chalks on paper,
47·4 × 41·6 (18⅝ × 16⅜)
s(trc): *DGR/ 1869* (mon)
Lloyd Roberts bequest (1920.643)

19, p. 44
Boatmen and siren c.1853
Ink on paper
11 × 18·4 (4 5/16 × 7¼)
Unsigned. Inscr(brc): *Lo marinaio oblia,/che
passa per tal via*
C. L. Rutherston gift (1925.133)

21, p. 46
Miss Siddal
Pencil on paper
28·7 × 14·8 ($11\frac{5}{16}$ × $5\frac{13}{16}$) sight
Unsigned
C. L. Rutherston gift (1925.253)

69, p. 102
Joli cœur 1867
Oil on panel
38·1 × 30·2 (15 × $11\frac{7}{8}$)
s(trc): *DGR 1867* (mon)
Miss A. E. F. Horniman bequest (1937.746)

59, p. 92
**Study of Guinevere for
'Sir Lancelot in the Queen's Chamber'**
(formerly **Woman's head**) 1857
Pencil and watercolour on paper
49·7 × 51·4 ($19\frac{9}{16}$ × $20\frac{1}{4}$)
s(trc): *Oxford/ 1857 DGR* (mon)
Inscr(tr): *fainting study*
G. Beatson Blair bequest 1941 (1947.149)

72, p. 108
Silence 1870
Pencil on paper
50·6 × 35·4 ($19\frac{15}{16}$ × $13\frac{15}{16}$)
Unsigned
Inscr(tr): 28 July/1870
G. Beatson Blair bequest 1941 (1947.150)

Frederick Sandys 1829–1904

68, p. 100 + colour plate VII, p. 19
Vivien 1863
Oil on canvas
64 × 52·5 ($25\frac{3}{16}$ × $20\frac{11}{16}$)
Unsigned. Inscr(blc): *1863*
Purchased (1925.70)

William Bell Scott 1811–1890

64, p. 98
**James reading Boethius
(for 'The King's Quair')** 1865/8
Pencil on paper
141·1 × 55·2 ($57\frac{1}{2}$ × 22)
Unsigned
Purchased (1974.41)

65, p. 98
**Lady Jane in the garden
(for 'The King's Quair')** 1865/8
Pencil on paper
148·6 × 56 ($58\frac{1}{2}$ × $22\frac{1}{16}$)
Unsigned
Purchased (1974.42)

66, p. 99
**The Court of Love
(for 'The King's Quair')** 1865/8
Pencil on paper
149·8 × 56·4 (59 × $22\frac{1}{4}$)
Unsigned
Purchased (1974.43)

67, p. 99
**James receiving Jane's carrier pigeon
(for 'The King's Quair')** 1865/8
Pencil on paper
150·5 × 55·7 ($59\frac{1}{4}$ × $21\frac{15}{16}$)
Unsigned
Purchased (1974.44)

Frederick Smallfield 1829–1915

41, p. 74
Early lovers (formerly **First love**) 1858
Oil on canvas
76·4 × 46·1 ($30\frac{1}{16}$ × $18\frac{1}{8}$)
s(brc): *Smallfield/1858*
Purchased (1903.7)

Simeon Solomon 1840–1905

76, p. 111
Study: female figure 1873
Watercolour, bodycolour and oil on paper
24·9 × 14·9 ($9\frac{13}{16}$ × $5\frac{7}{8}$) sight
s(blc): *SS/73* (mon)
Guy Knowles gift (1933.70)

77, p. 111
Study: male figure 1878
Oil on paper
32 × 18·1 ($12\frac{5}{8}$ × $7\frac{1}{8}$) sight
s(blc): *SS/1878*
Guy Knowles gift (1933.71)

J. R. Spencer Stanhope 1829–1908

110, p. 137
Eve tempted Exh. 1877
Tempera on panel
161·2 × 75·5 ($63\frac{7}{16}$ × $29\frac{3}{4}$)
Unsigned
John Slagg M.P. gift (1833.29)

111, p. 138
**The waters of Lethe by the plains of
Elysium** Exh. 1880
Tempera with gold paint on canvas
147·5 × 282·4 ($58\frac{1}{16}$ × $111\frac{1}{8}$)
Unsigned
Gift of the artist (1889.4)

John Melhuish Strudwick
1849–1937

113, p. 141
**When apples were golden and songs were
sweet, But summer had passed away**
Exh. 1906
Oil on canvas
76·4 × 48·4 ($30\frac{1}{16}$ × $19\frac{1}{16}$)
Unsigned
Purchased (1906.103)

John William Waterhouse
1849–1917

112, p. 139
Hylas and the nymphs 1896
Oil on canvas
98·2 × 163·3 ($38\frac{11}{16}$ × $64\frac{1}{4}$)
s(brc): *J. W. Waterhouse/1896*
Purchased (1896.15)

William J. Webb fl. 1853–1878

46, p. 79
The lost sheep 1864
Oil on panel
33·1 × 25·1 ($13\frac{1}{16}$ × $9\frac{7}{8}$)
s(brc): *18 WJW 64* (mon)
Purchased (1920.94)

William Lindsay Windus
1823–1907

44, p. 78
The outlaw 1861
Oil on canvas, arched top
35·7 × 34·3 ($14\frac{1}{16}$ × $13\frac{1}{2}$)
Unsigned
Sir Thomas D. Barlow gift (1937.28)

45, p. 78
Samuel Teed
Oil on canvas
71·7 × 61 ($28\frac{1}{4}$ × 24)
Unsigned
Major P. L. Teed gift (1954.1058)

Not illustrated
**Iron, Weaving, Shipping, Spinning,
Commerce, Corn, Wool**
(Decorations for the Royal Jubilee Exhibition,
Manchester 1887)
All oil on canvas
Approx. 400cm square
Unsigned
Edgar Wood gift (1926.77–83)

Other illustrations

2